Regarding Emma

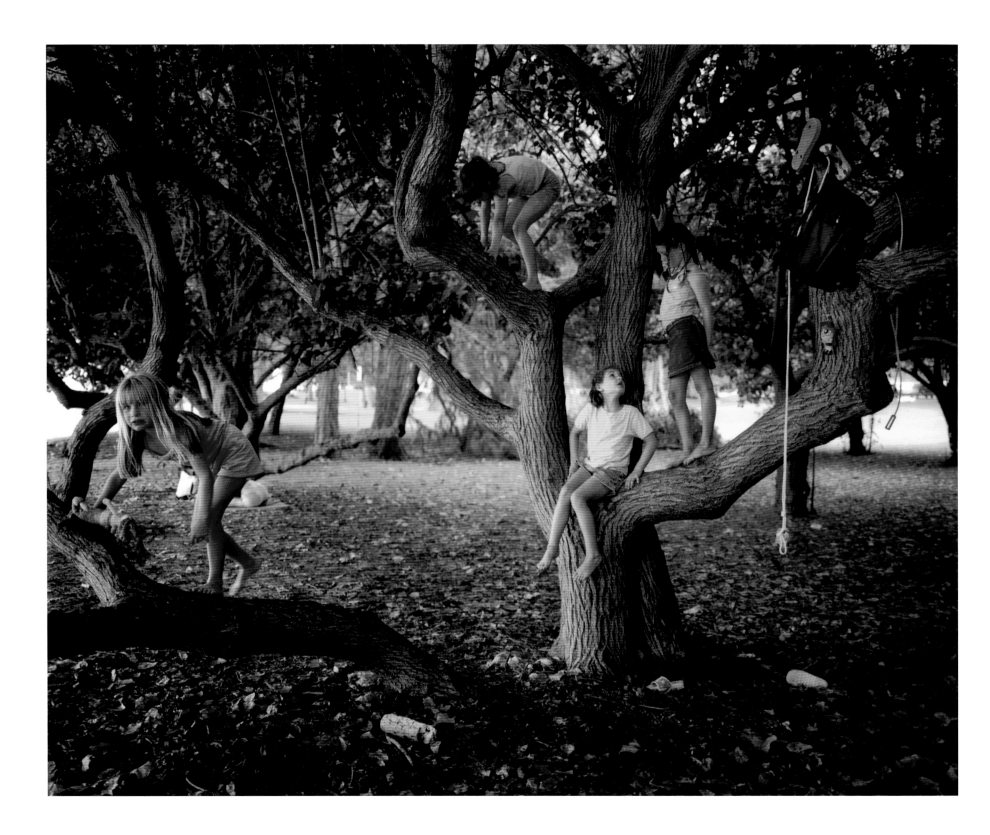

Regarding Emma

PHOTOGRAPHS OF AMERICAN WOMEN AND GIRLS

Melissa Ann Pinney

WITH A FOREWORD BY ANN PATCHETT

The Center for American Places
Santa Fe, New Mexico, and Harrisonburg, Virgina

in association with

Columbia
COLLEGE CHICAGO |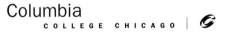

Publisher's Notes

This book was brought to publication in an edition of 2,500 clothbound copies with the generous financial assistance of Jeanne and Richard S. Press and Nancy and Ralph Segall, and also Jack Jaffe and Naomi Stern, Michael Lenehan and Mary Williams, and Robert Roth for which the publisher is most grateful. The publisher extends special appreciation to Bob Thall, professor and chairman of the Photography Department at Columbia College Chicago, for all his efforts on behalf of photography and this book. For more information about the Center for American Places and the publication of *Regarding Emma: Photographs of American Women and Girls,* please see page 106.

Copyright © 2003 Center for American Places
Photographs and preface copyright © 2003 Melissa Ann Pinney
All rights reserved
Published 2003. First edition.
Printed in Iceland on acid-free paper.

Center for American Places, Inc.
P.O. Box 23225
Santa Fe, New Mexico 87502, U.S.A.
www.americanplaces.org

Distributed by the University of Chicago Press
www.press.uchicago.edu
9 8 7 6 5 4 3 2 1

Library of Congress Cataloging-in-Publication Data is available from the publisher upon request.
1-930066-14-7

Contents

Foreword

BY ANN PATCHETT

When I was a college student looking for ways to come up with the weekly stories that were due in my fiction class, I often turned to books of photography for assistance. It is an easy form of plagiarism that is nearly impossible to detect, as a good photograph doesn't so much give you the story as it gives you the moment a story turns on: a child pointing a plastic gun in front of a stack of Christmas trees, a father and daughter looking away from one another in a car. These are the subtle, almost invisible moments in which everything changes. Sometimes the camera catches something obviously pivotal: a wedding, a baby. Other times it simply records the movement of time: a child who is changing so quickly she will only be this person for one more minute and then, in a sense, she is so grown up she is gone forever.

Look at the photographs in this book. The frames are crowded with stories. Daughters and mothers, women and men, revealing so much of themselves at times I had to turn away from the pages to catch my breath. The children will, as children do, command all of our attention at first. There is no denying the beauty of youth, the shimmering light that comes from having spent so little time in new skin. But the real gorgeousness of these children is in their possibility. What will you be? Who will you become? Children have yet to fail at anything. For a moment there is the chance to believe that no door is shut. It's part of our drive to reproduce in the first place, to push the re-set button, if not for ourselves then at least for something that is part of us.

The little girls in Melissa Ann Pinney's photographs are never once a blank slate. Even the smallest of them is etched with the full weight of her will, her personality. It isn't so much that anything might happen to them, but instead that we haven't learned to read them well enough to know the whole truth. The stories of their lives are still encoded, even as they are barreling forward in time. They reach their little hands across these pages to the older women in the book, proving they are one and the same. Every old woman was once the baby girl whose mother kissed her sweet toes. Every girl has inside herself the very soul that will one day shape an old woman of her own.

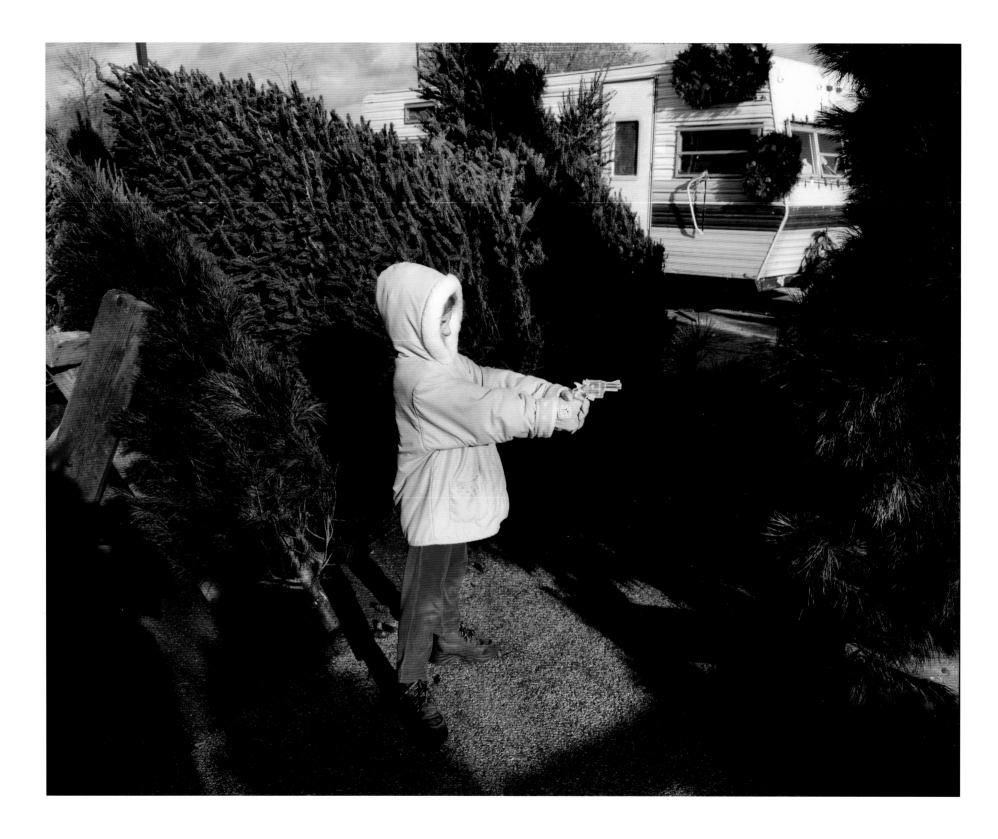

Melissa Ann Pinney is making powerful art. In matters of light, color, and composition she is flawless. But these are not simply constructions of elements. These photographs bear witness to the speed at which the little girl becomes the old woman, to the fleeting, breathless beauty of childhood, to life itself, which leaves us stunned in its wake. There is no way to slow anything down, to keep the two edges of the continuum apart. There is nothing to do but cut out a single instant from the stream of the day and see the desolate, heartbreaking beauty of being, for this second, alive. There are the weddings, birthdays that come sticky with frosting, hopeful, awkward dances, moments that should prove how we're united and yet seem instead to suspend every soul in his or her own isolation, each staring off in a separate direction, wondering about what's coming next. Take instead the days with no expectations— climbing a tree, a walk on a beach, the joy that comes of a swimming pool or pouring water from a cup—and suddenly we can be ourselves again, quietly together.

The women in this book form a society, and their lives, desires, and losses inform each other as they grow. They direct our imagination to all the women who stand just outside the frame, the ones who have died as well as the ones on the other end of the spectrum, the pregnant woman pulling up her shirt to show her belly, and the baby that *that* baby will one day grow up to give birth to. They are all together in these pictures. The power of their collective love, disappointments, and strength is the power of these images.

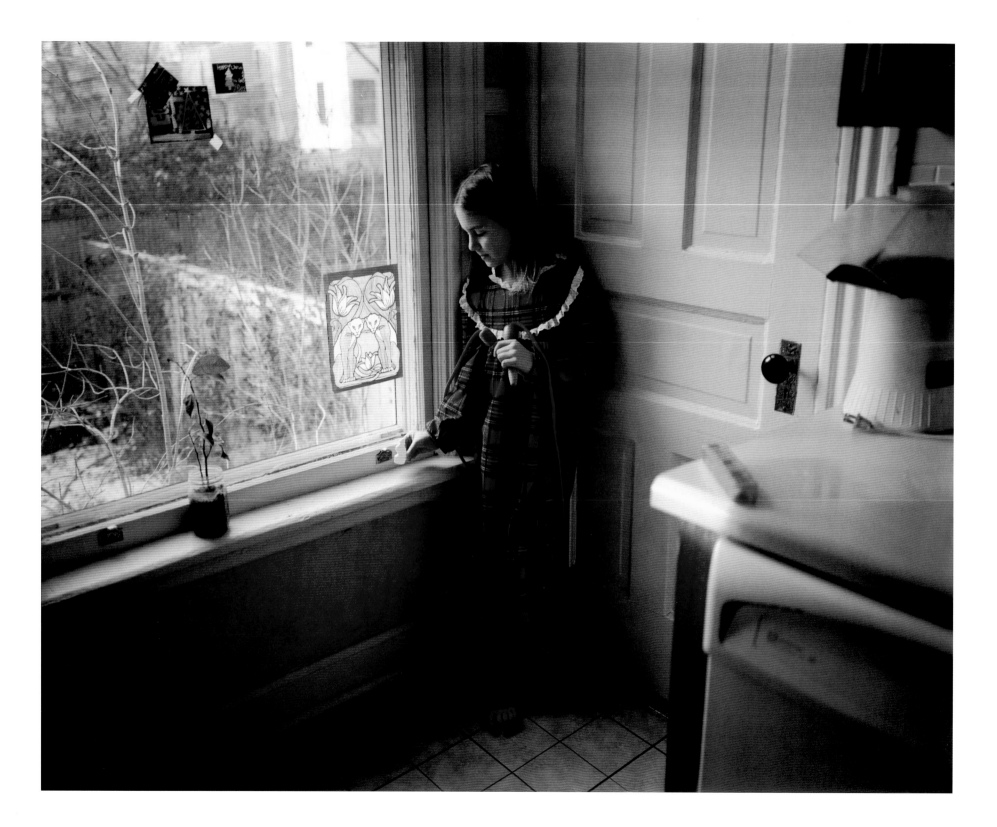

Preface

BY MELISSA ANN PINNEY

As a child of eight years old, I remember feeling compelled to make something, to have a work that was my own. Painting seemed too grand and intimidating, sewing too mundane and stereotypically feminine. It was not until college that I stumbled into photography and it felt like mine. I understood immediately that making photographs begins with attentive observation of the world. Since then, I have come to understand that on a good day such mindfulness is rewarded by images more authentic and more mysterious than any I could have imagined beforehand.

The photographs in this book are based on my experiences growing up. Raised as a Catholic with five brothers and two sisters, I learned early on that girls had to fight for most everything: to get and keep one's share, for credit and recognition, to state one's view of things. An image that comes to mind is of my older brother leaning out of his chair at the dinner table, reaching over to spear my piece of chicken with his fork. We three girls were "mother's helpers." While my brothers also had chores, I could not imagine any one of them polishing the silver or sweeping the kitchen floor. I railed at the double standard that provoked my question, "How come he gets to do that and I can't?" The response, "Because he's a boy," never changed. In our house, all things female were somehow suspect, inferior, unappreciated—in a word, domestic.

Before my generation in the 1960s, many Catholic schoolgirls wanted to become nuns. But to me the rank of the parish nuns in the church's hierarchy was not unlike that of a wife to a husband or a nurse to a doctor: a position of subordinate status and lesser rewards. Obsessively reading *The Lives of the Saints* in middle school, I was fascinated by the stories of young women passionately dedicated to God, possessed by a profound spirituality for which they were prepared to suffer. The female saints were compelling role models, courageous in the rigor of their lives and in their autonomy.

When I found the courage to articulate my views, it was by way of wordless photographs that depict precisely what has often been considered insignificant in the domestic, social, or cultural sphere. Weddings are an example. Perhaps because of its primary association with women, wedding photography has traditionally been a denigrated branch of the profession, a poor cousin to the glamour of fashion or advertising. Although I started photographing weddings initially to pay my bills, it was in doing so that I was given the gift of my subject matter. *Chicago, Illinois, 1985* (*Bride with Her Mother and Attendants*; see page 61) is a picture made on assignment that nonetheless signaled a turning point in my work, becoming the source of the series *Feminine Identity*. Taking the wedding ritual as a starting point, the pictures in this series look ahead to older women, then back to girlhood to see how our dreams and expectations of women are made visible; how feminine identity is constructed, taught, and communicated between mothers and daughters.

Even before my daughter Emma was born I photographed girls. Again and again they appeared on my proof sheets: held in their mother's arms, playing on the beach, or all dressed up for Halloween. While these are not images of me as a child, I have nonetheless come to think of them as being about my girlhood. Almost eight years ago I began a series of photographs about Emma, thinking of the two projects as separate. But in photographing our family life together and in regarding Emma day by day, it has become clear that girlhood lies at the heart of both projects. This book reflects that understanding and widens the scope of my work to include men in relation to these girls: as fathers, grandfathers, husbands, and brothers. Two projects are therefore joined: the long-term series *Feminine Identity* and photographs of my daughter Emma begun at her birth. When I began the series *Feminine Identity* in 1987, I focused mostly on adult women. My understanding of these subjects has inevitably grown, as I have grown, from being a daughter to becoming a mother.

My mother, at seventy years of age, told me that every time she looked in the mirror she wondered who "that old bat" was looking back at her. In her mind's eye, she still had the face she had at eighteen. This after eight children and forty years of marriage. I think of my mother's words now, ten years after her death, as I gather the photographs for this book. In my photographs I see the early cultivation of the woman-in-the-girl and the corresponding persistence of the child-in-the-woman to which my mother referred. Girlhood may be understood as a part of a continuum that women revisit, regardless of age, as Emma allows me to revisit and photograph aspects of girlhood in a way not possible before she was born.

My mother said she knew nothing about my work, but she knew enough to scout out interesting places for me to photograph when I visited her in Florida. Now I am able to recognize the generosity of these excursions and to acknowledge the connections photography has created among the generations of women in my family. Estranged from my mother for many months, she called me, urgently asking me to fly down to Florida. I understood then that she was dying, and I went to say goodbye. Dozing most of the time, her skin took on a palpable glow; her hair was completely white and longer than it had been in years. I brushed her hair as she used to brush mine. I wanted to photograph this new, ethereal beauty then as I had always photographed her. When I got my camera she said, "You don't want to remember me like this." But, of course, I did want to remember her just like that, and I've regretted not making that picture ever since.

Long ago I gave up my desire to become a saint. Now I am an artist. But the biblical imagery, the importance of ritual, and the sacramental view of life I experienced as a girl remain deeply embedded in the way I see.

In memory of my mother, Mary Ann Hilburn Pinney,
and for my father, William Thomas Pinney

Regarding Emma

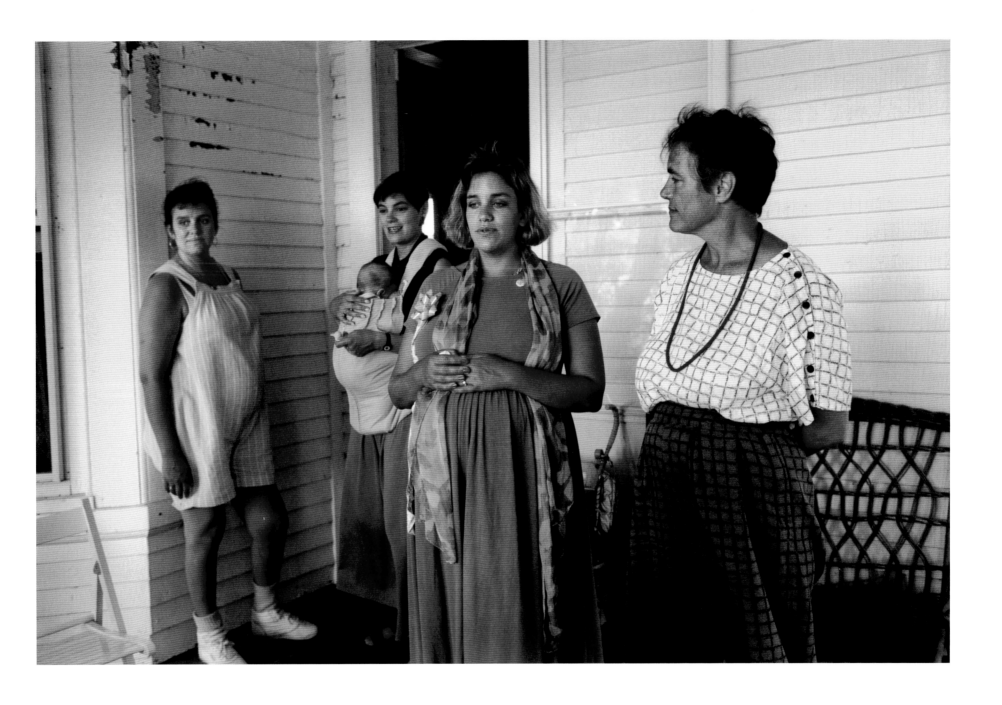

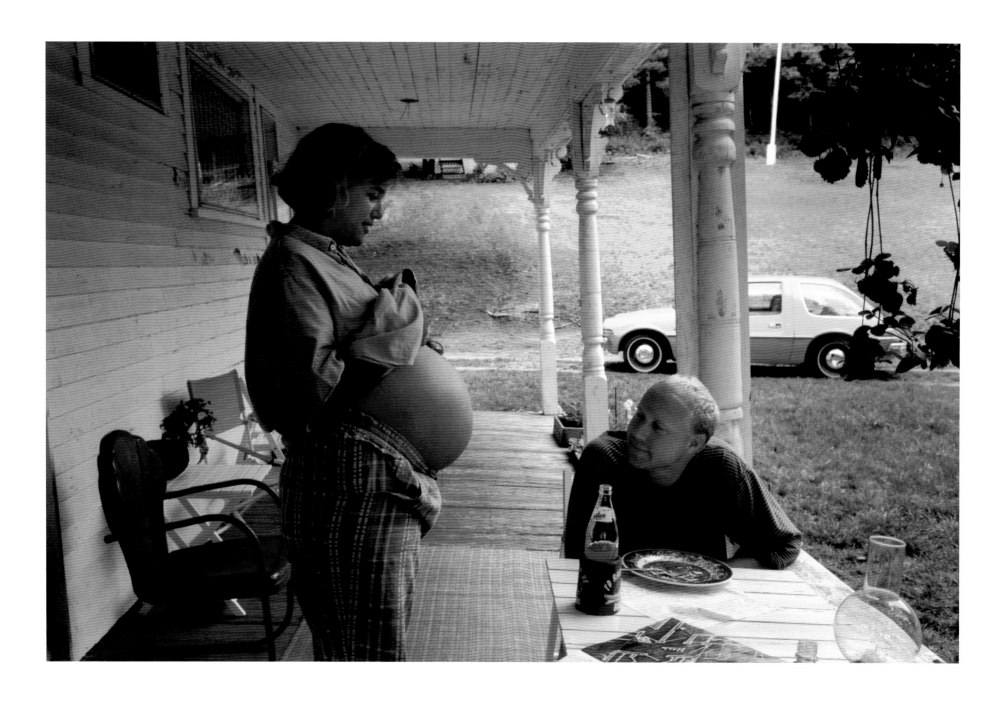

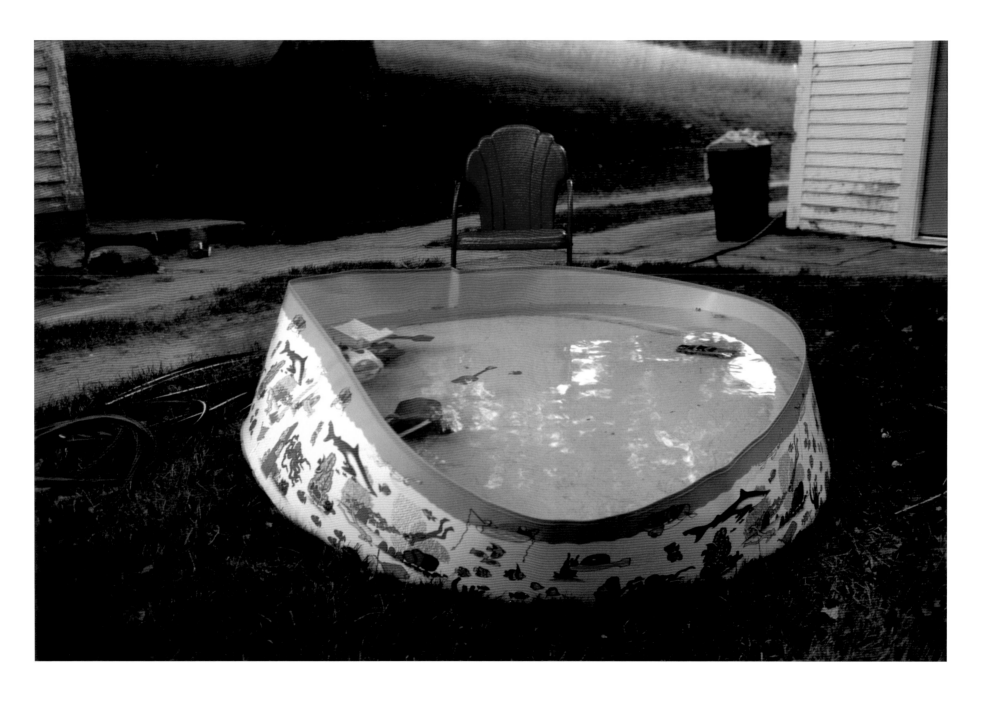

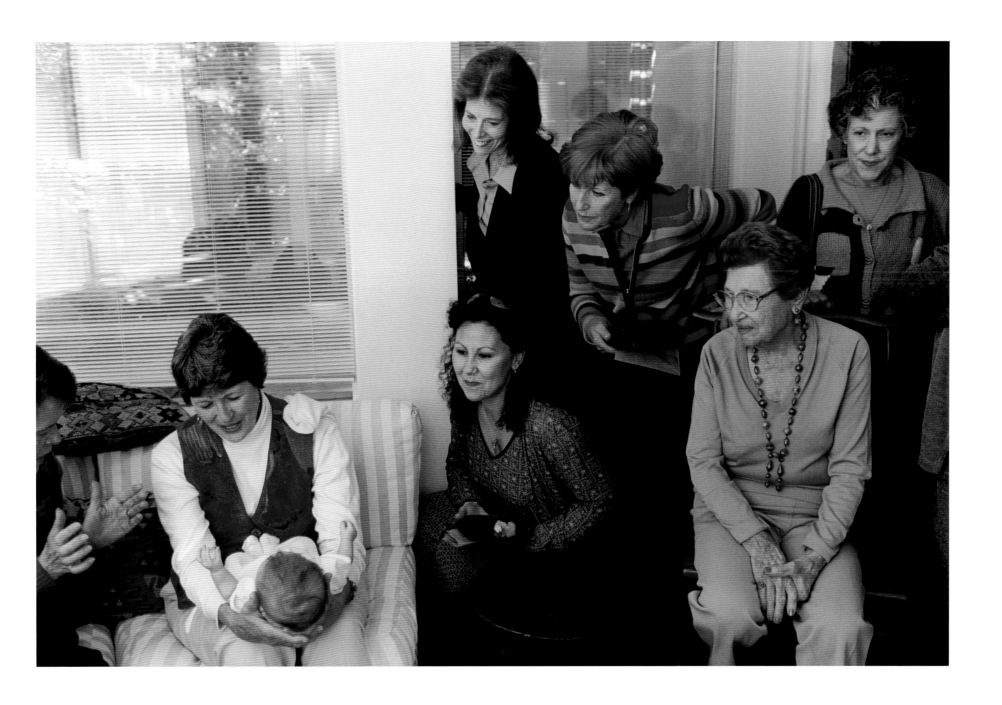

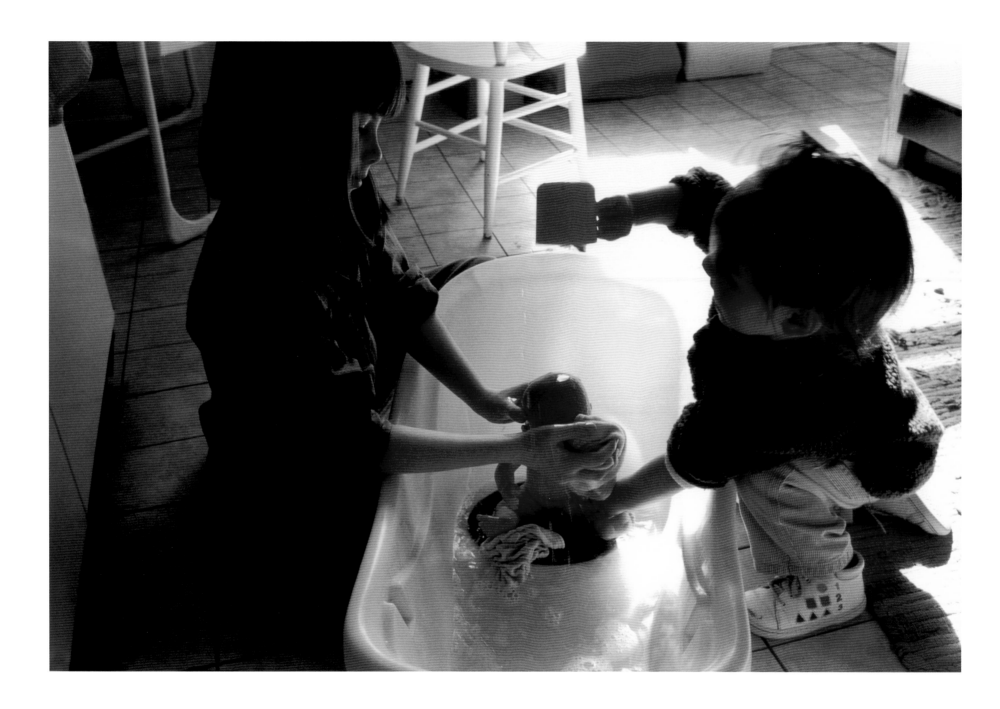

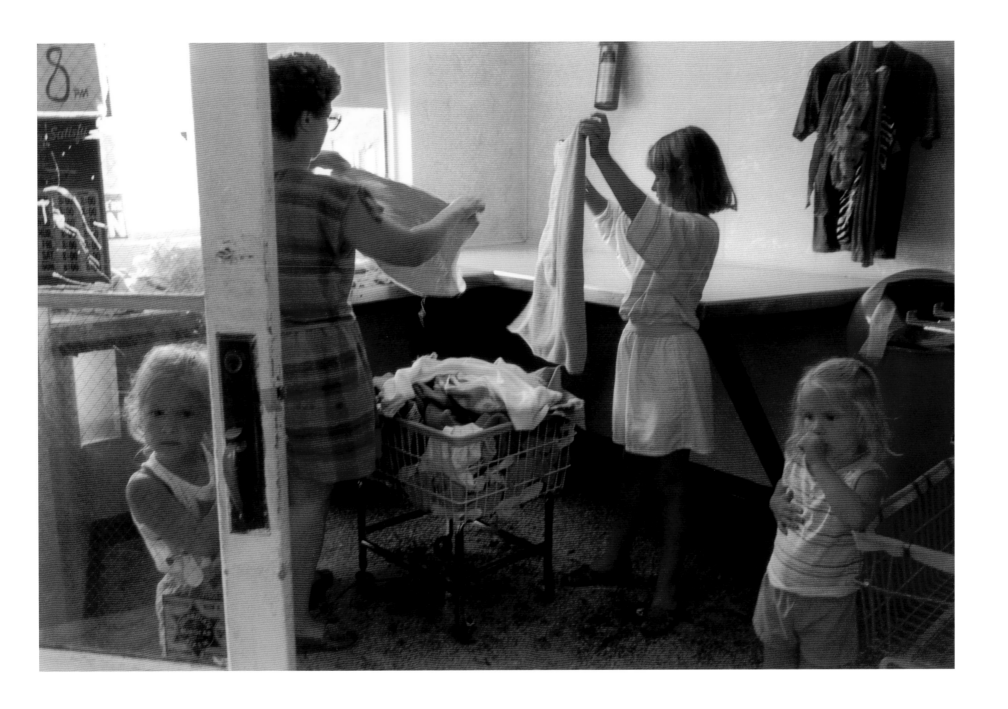

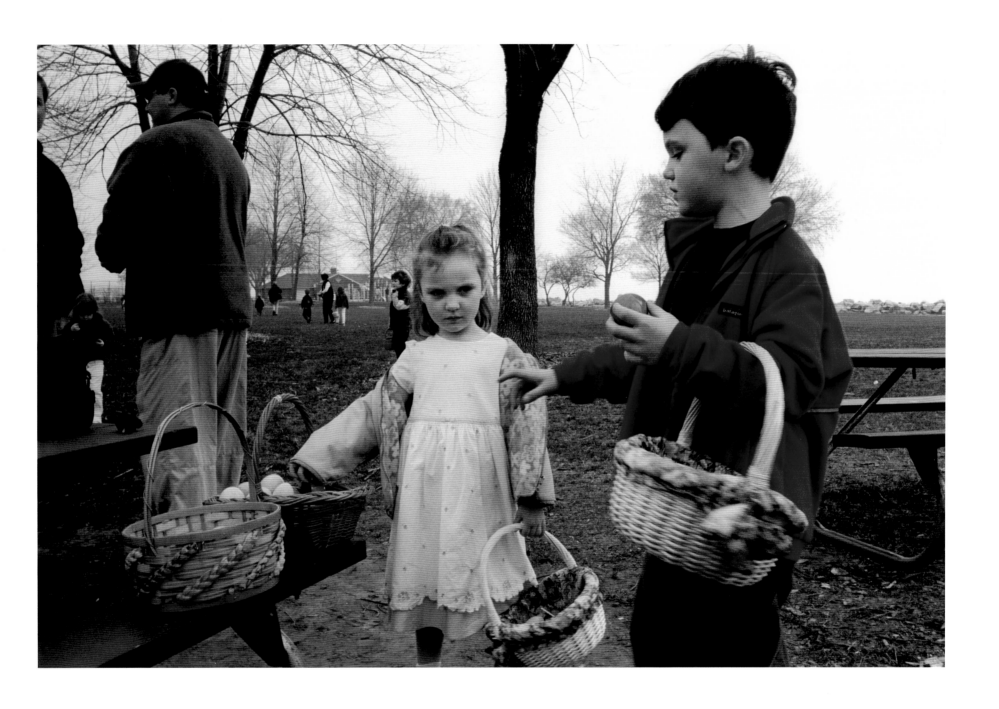

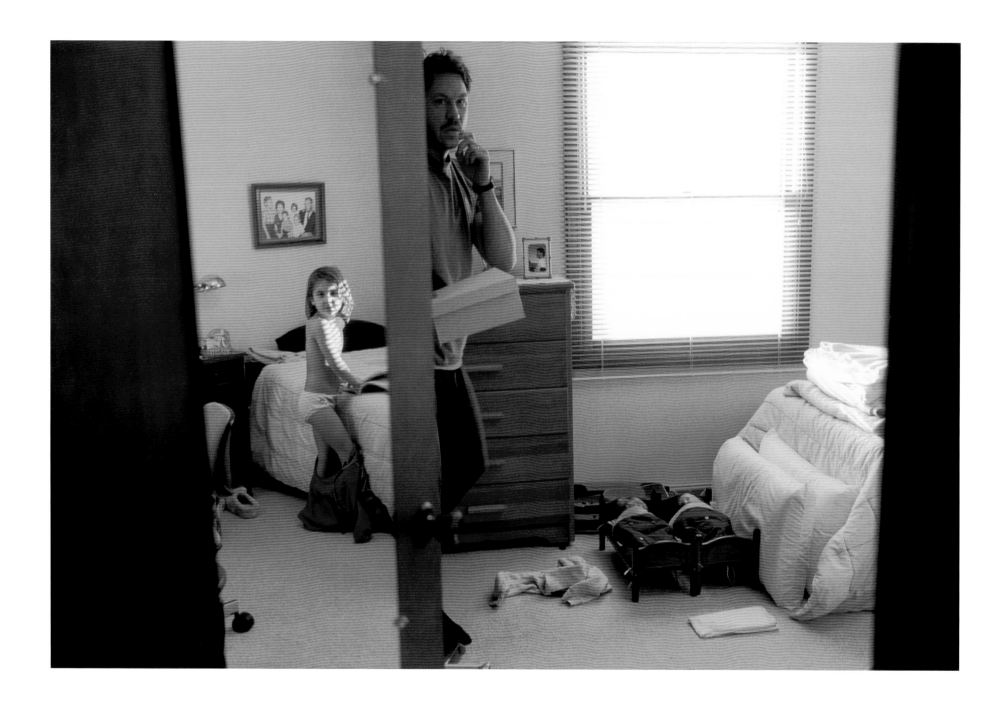

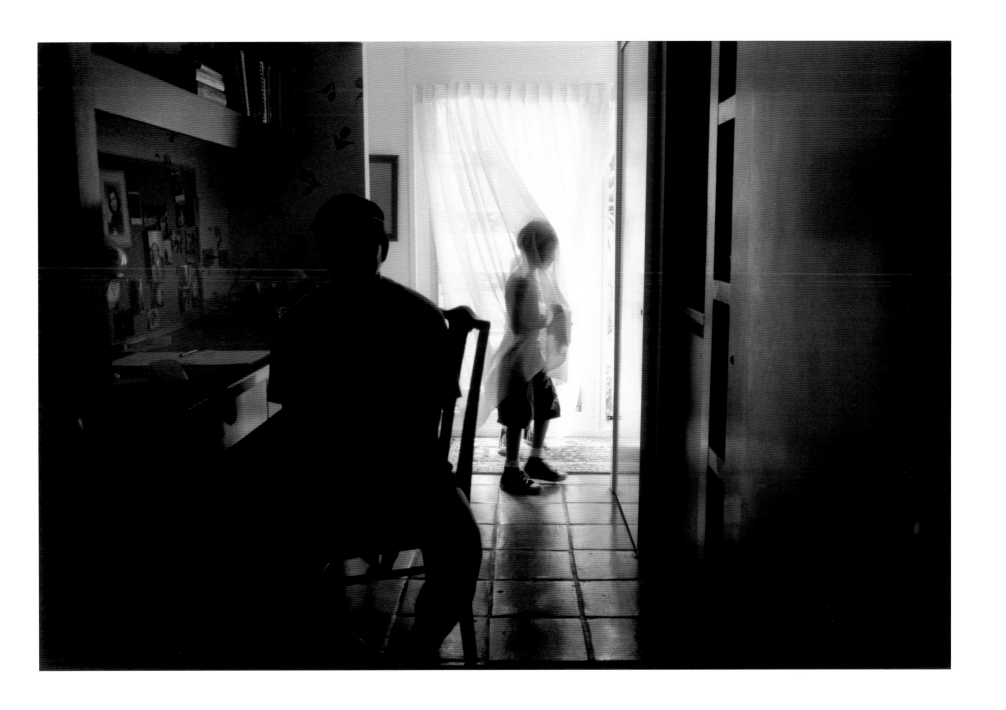

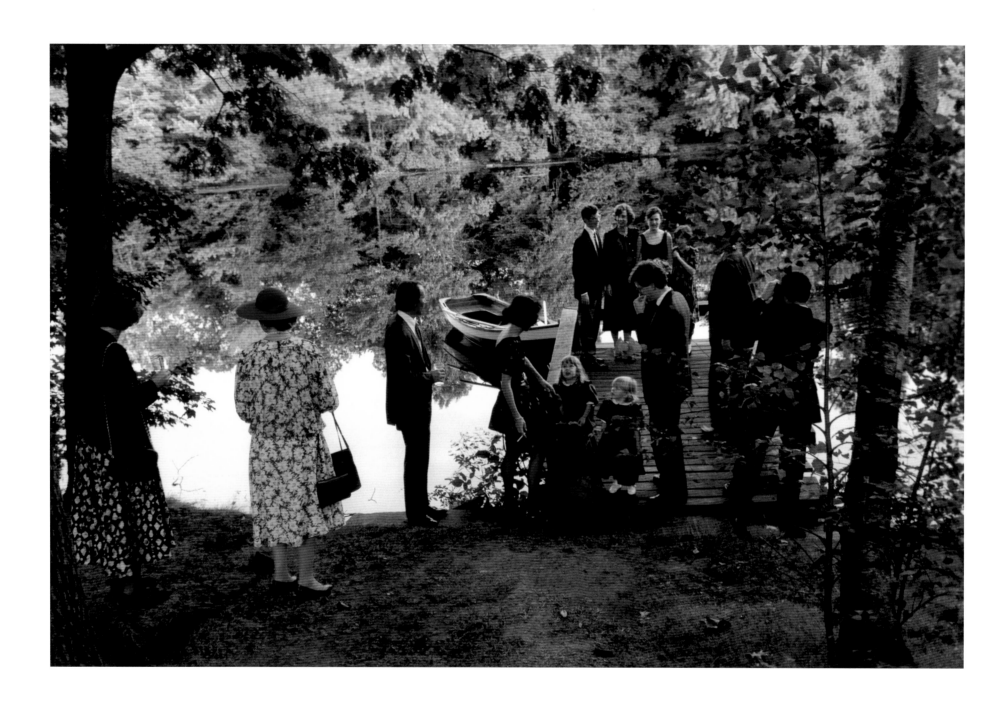

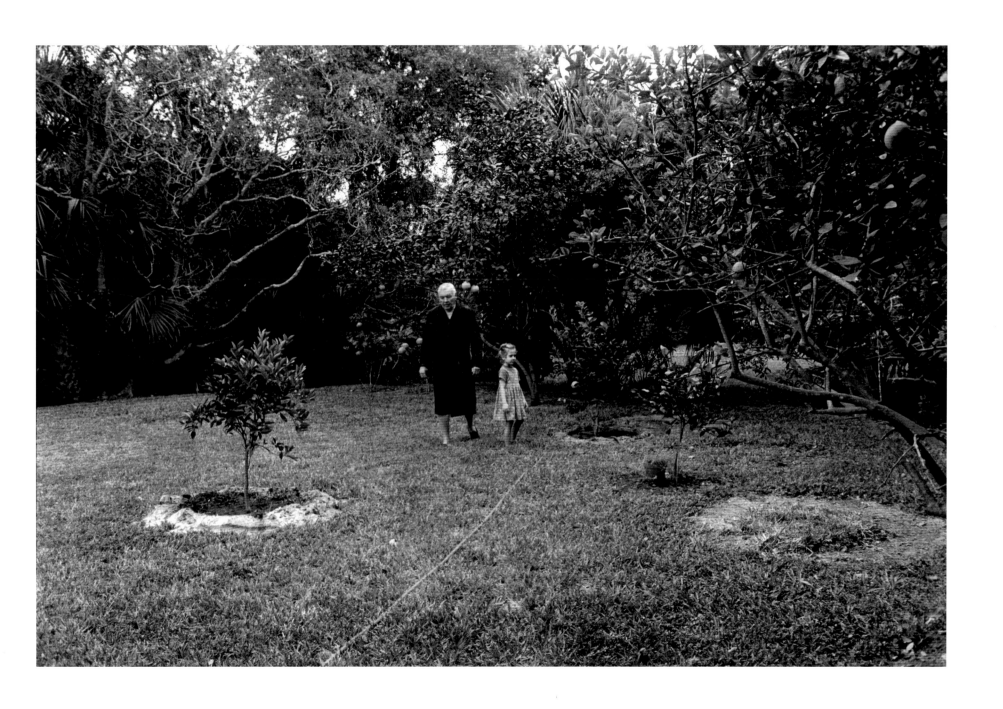

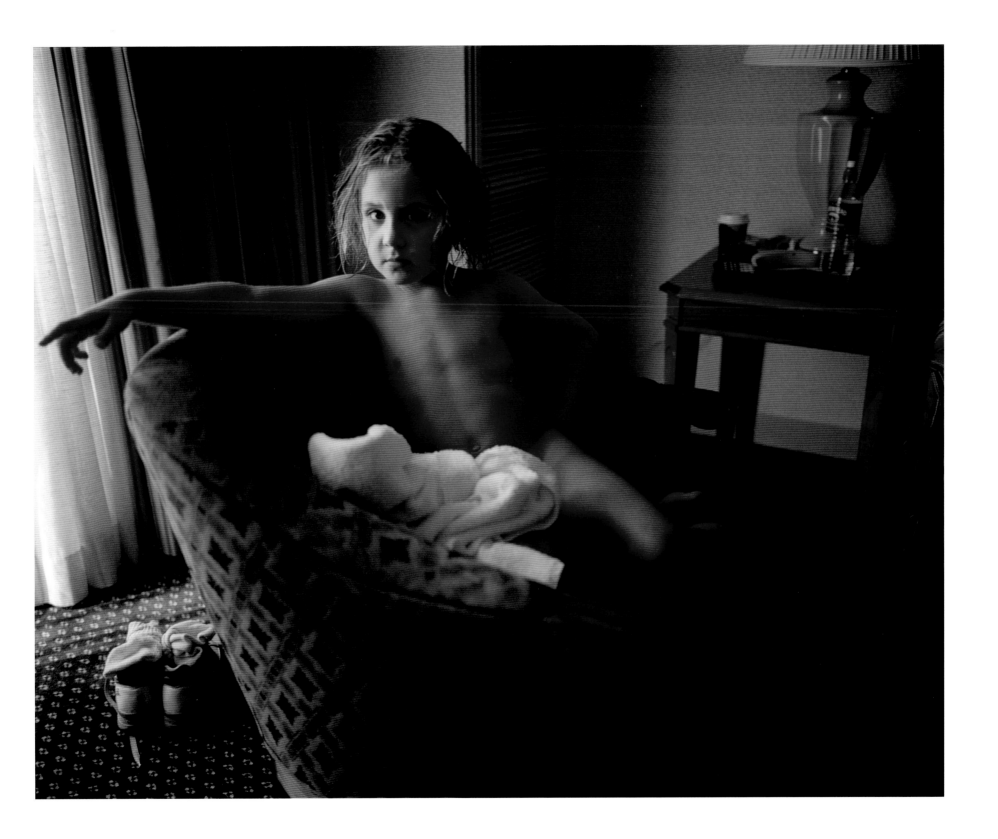

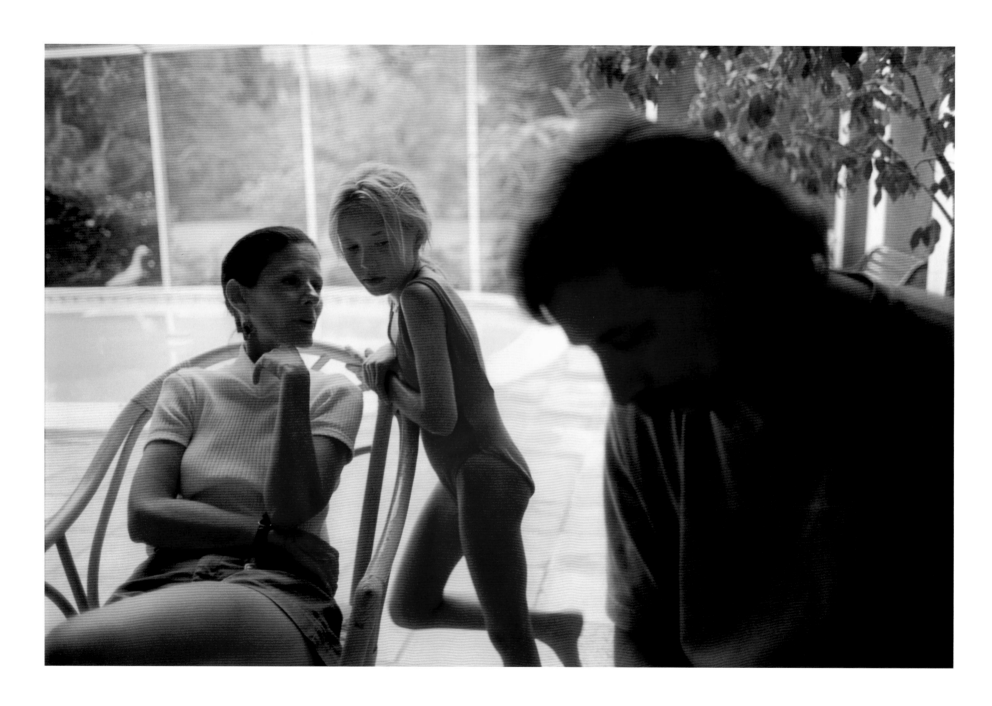

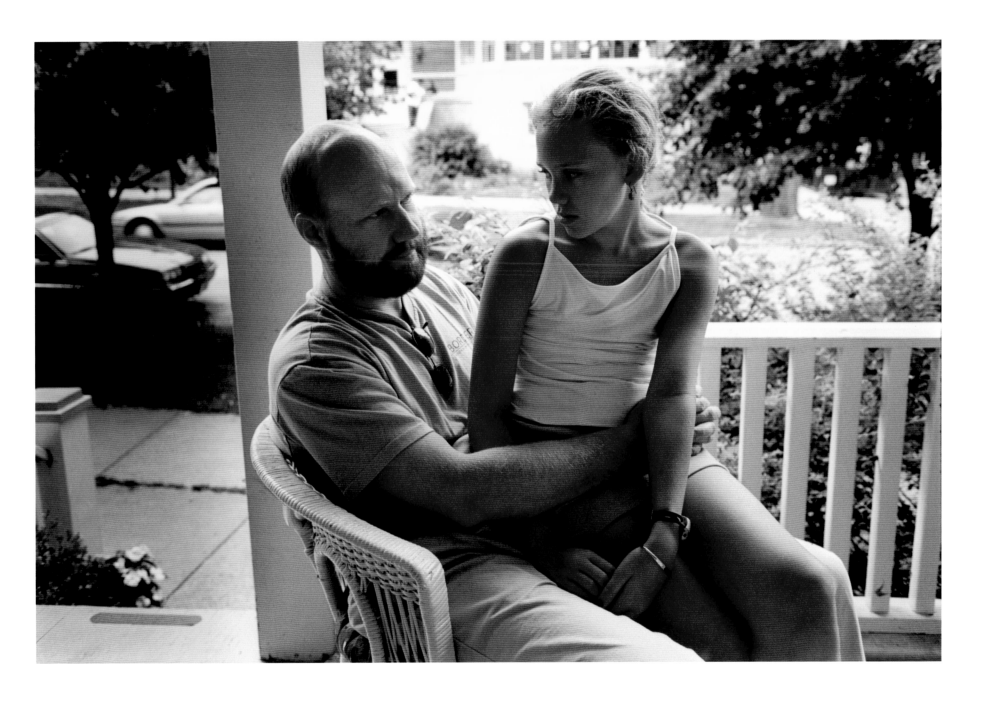

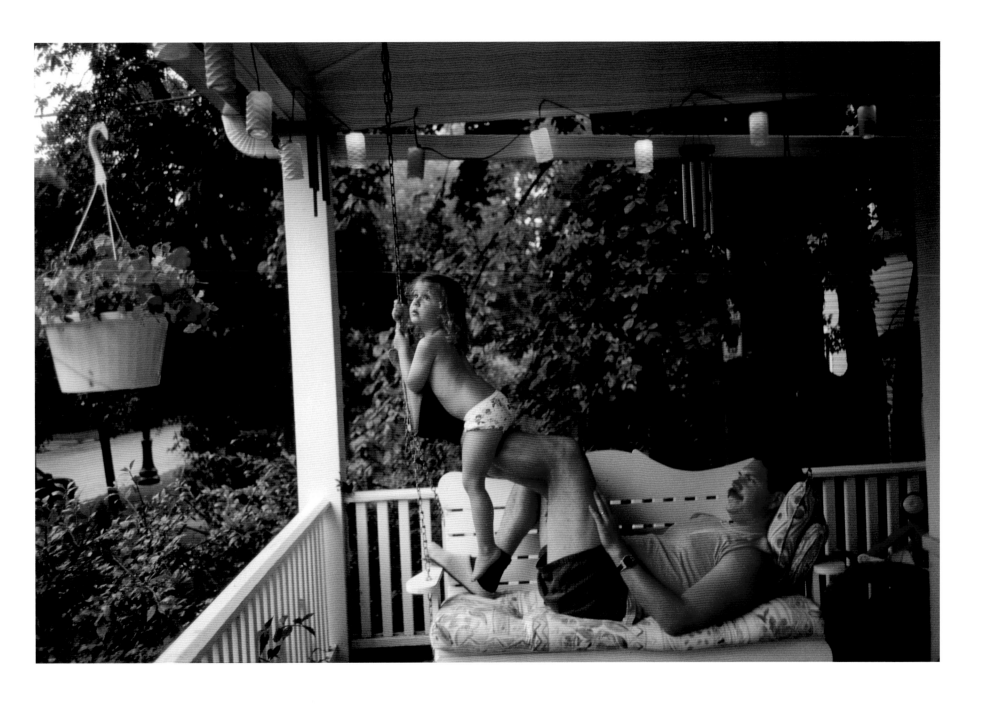

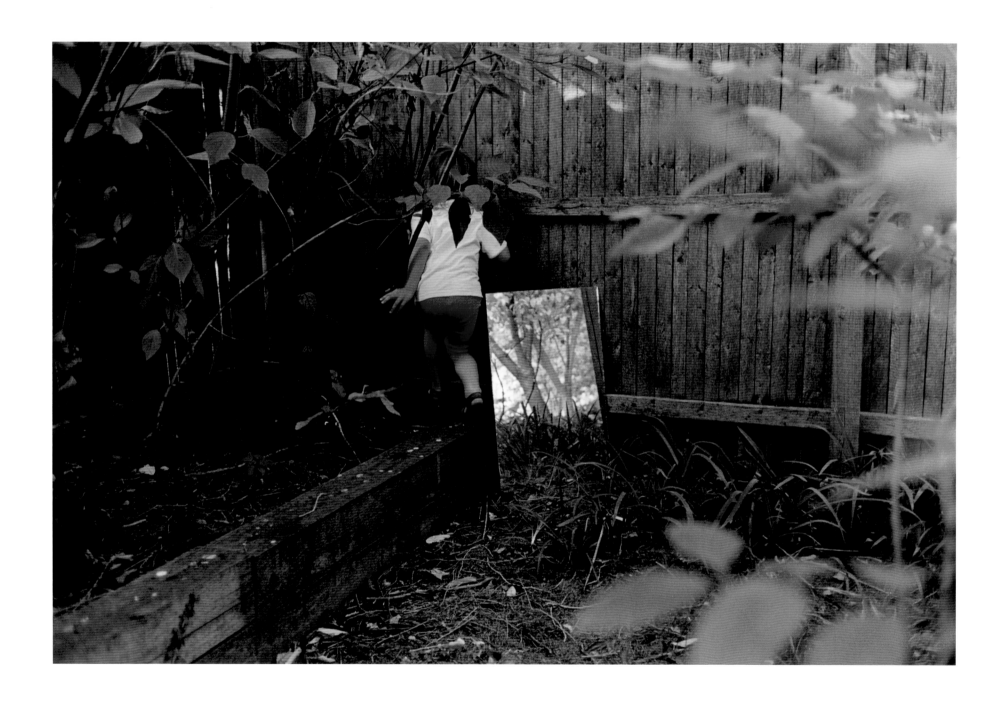

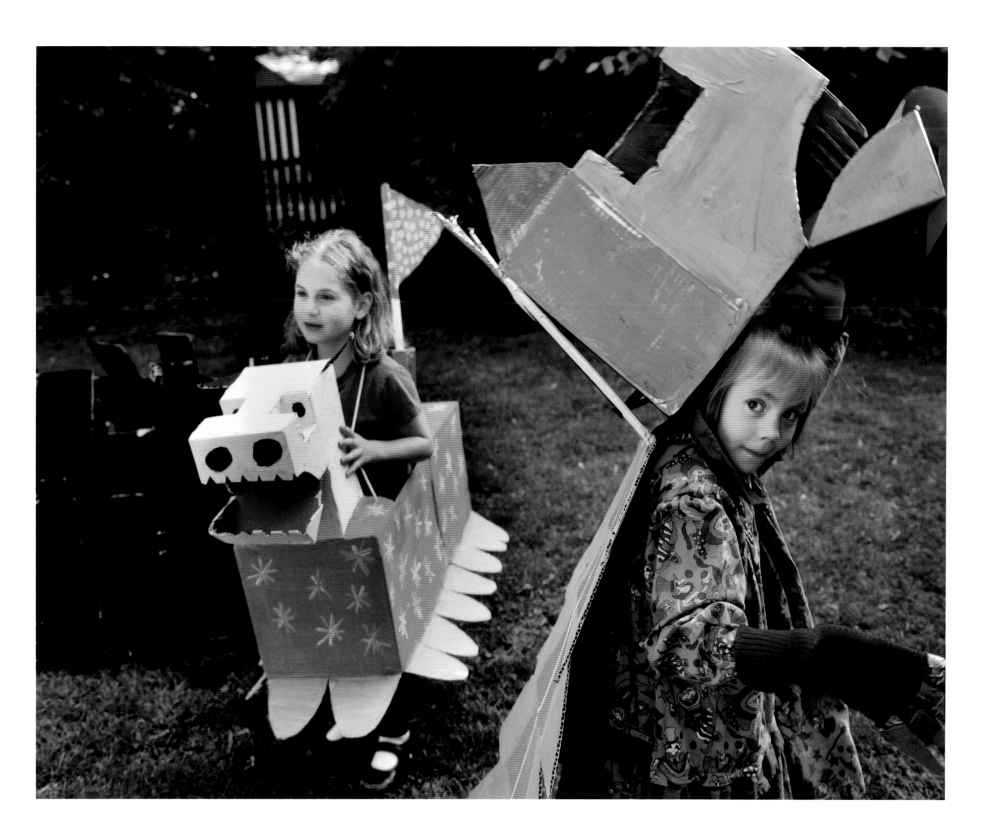

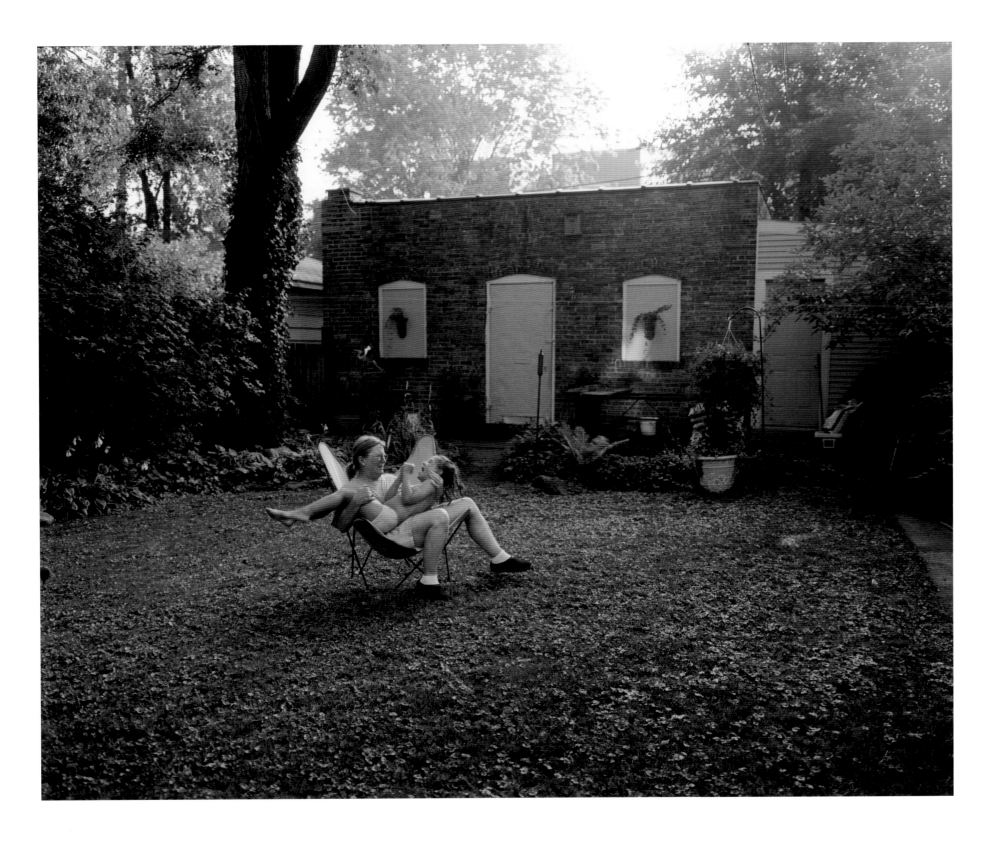

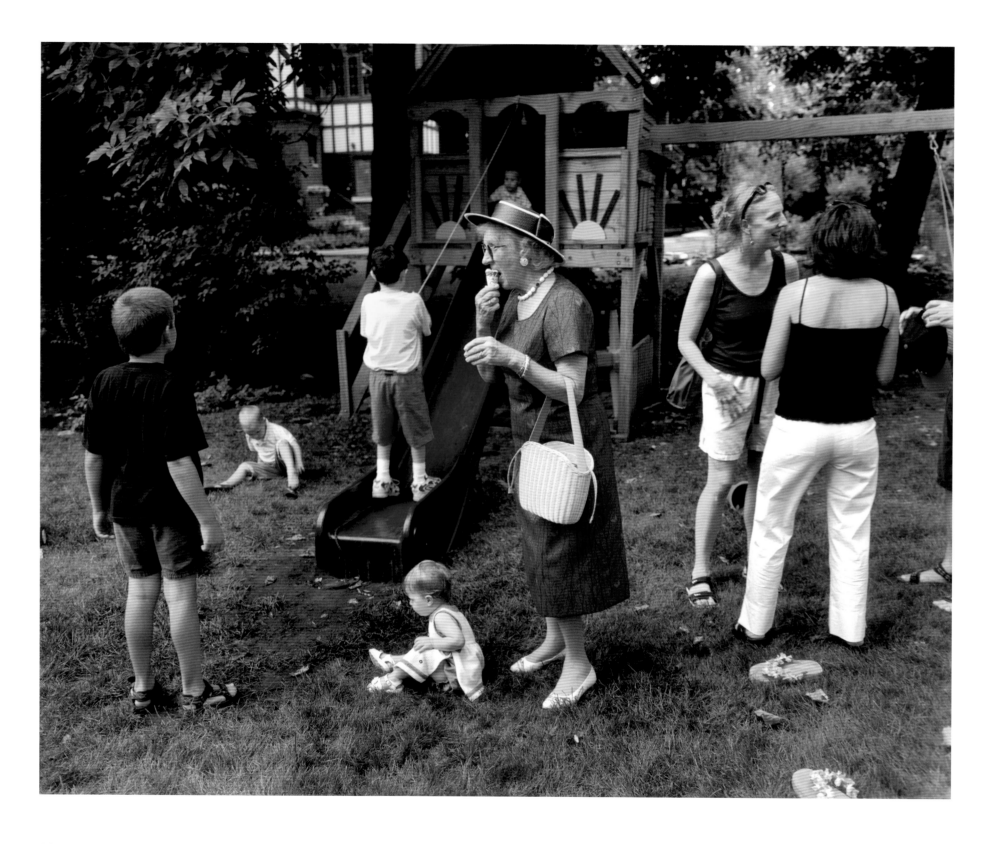

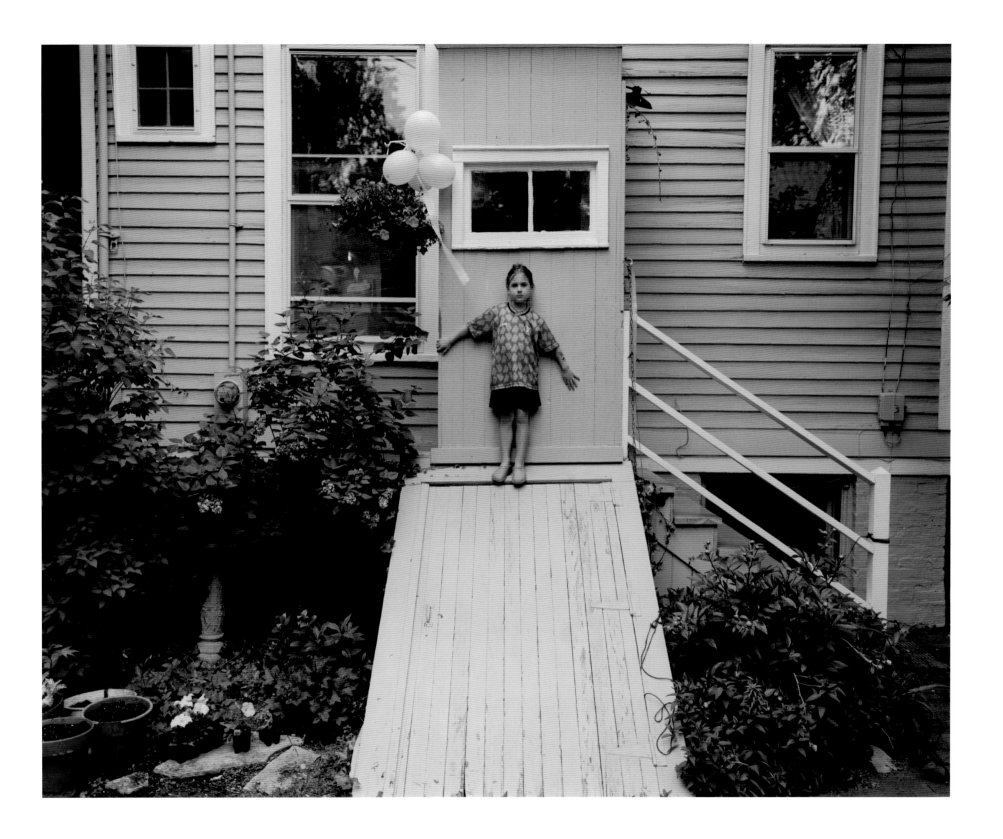

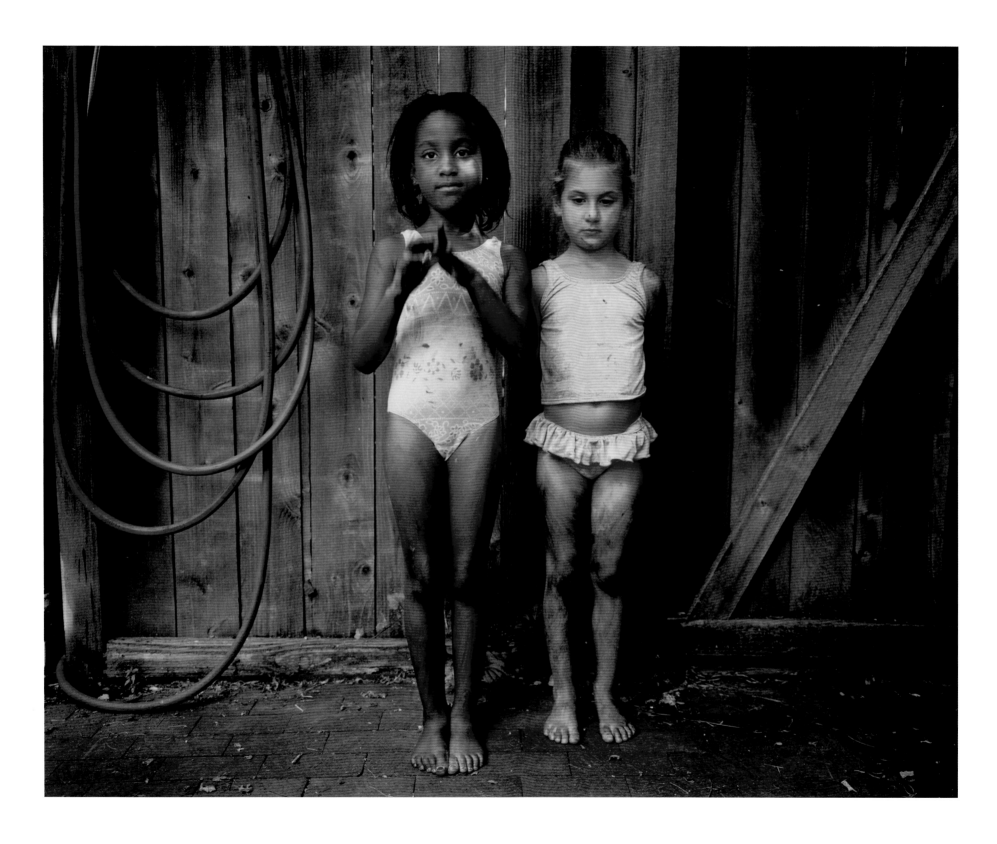

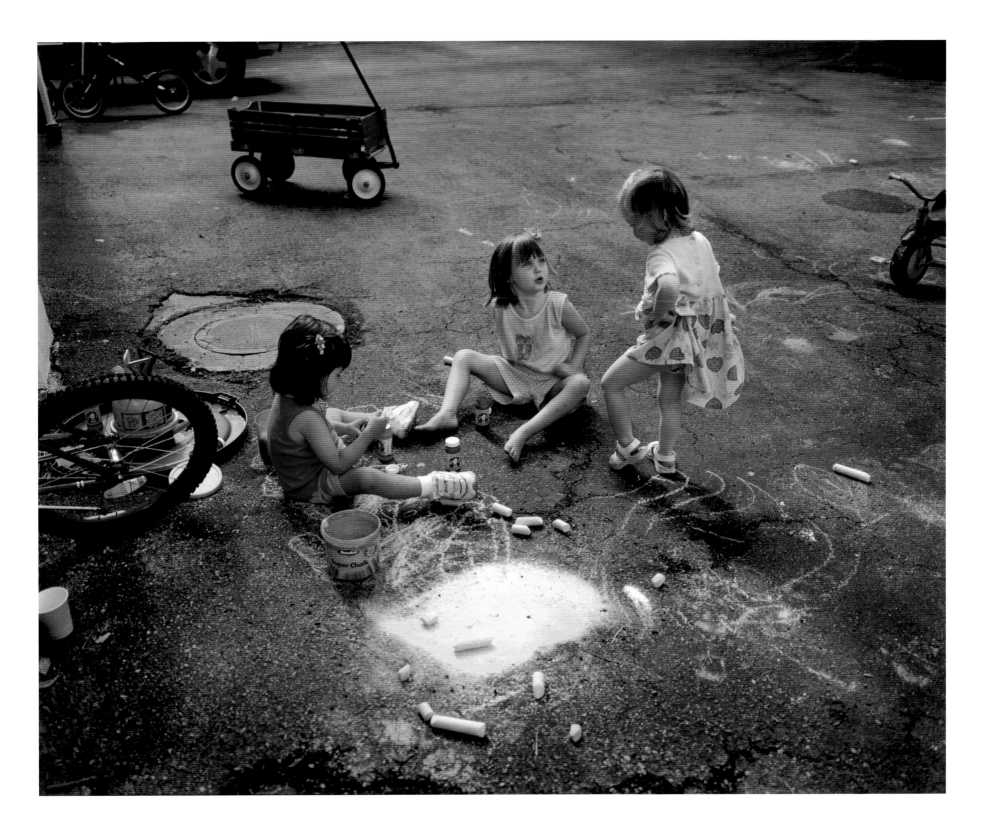

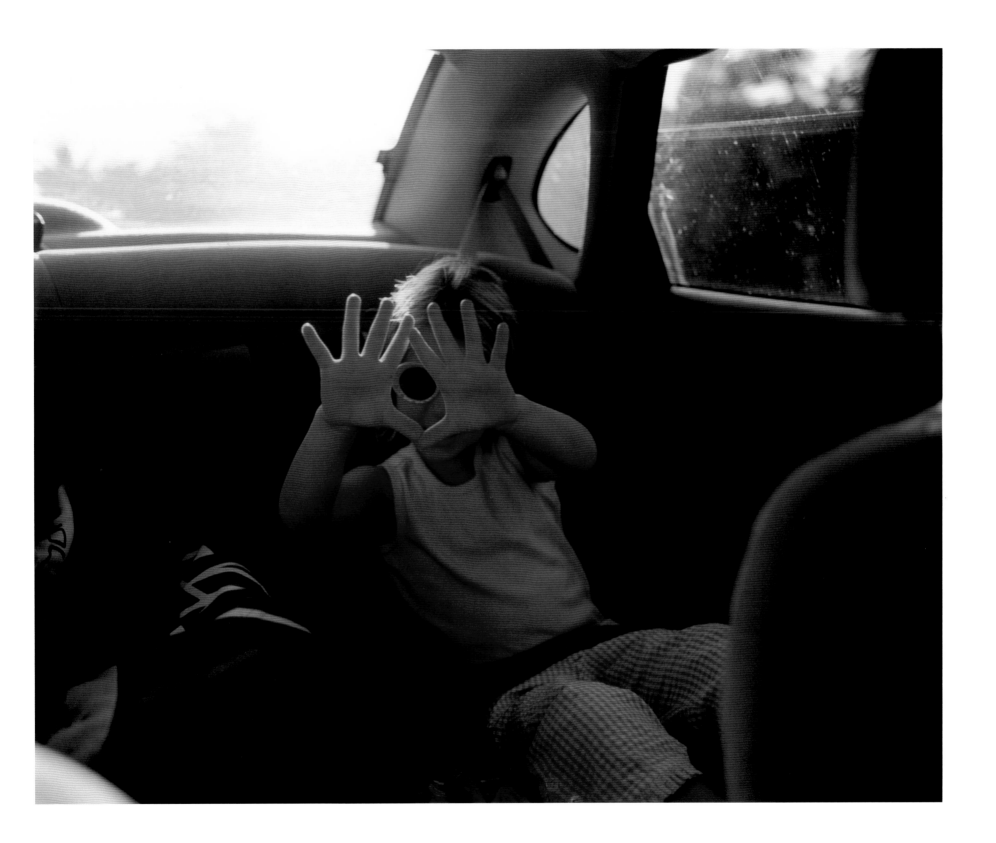

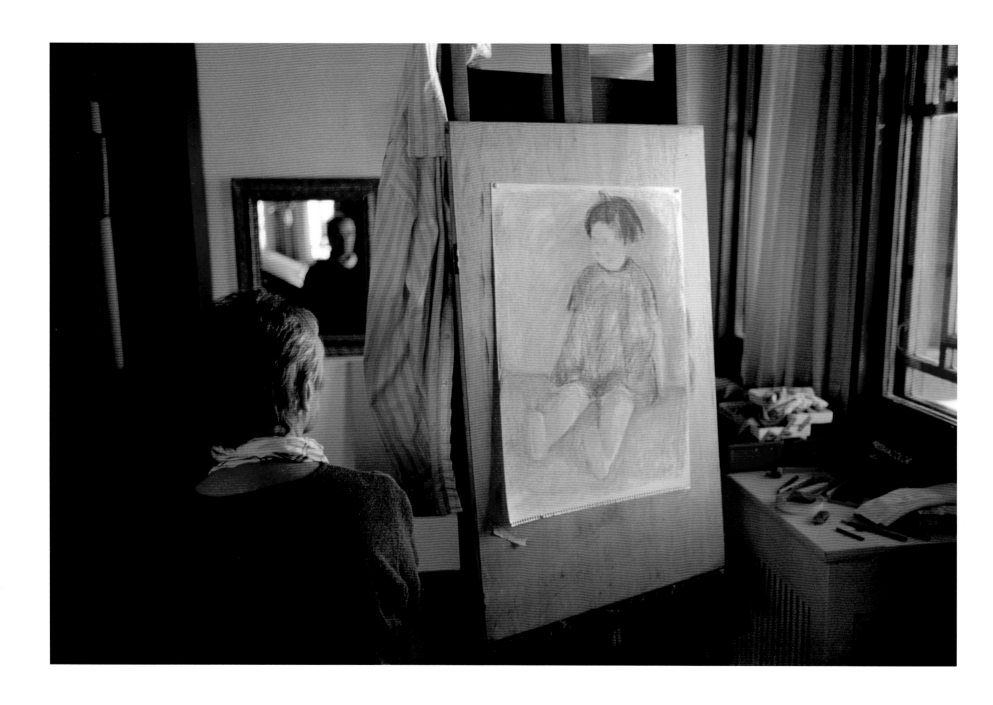

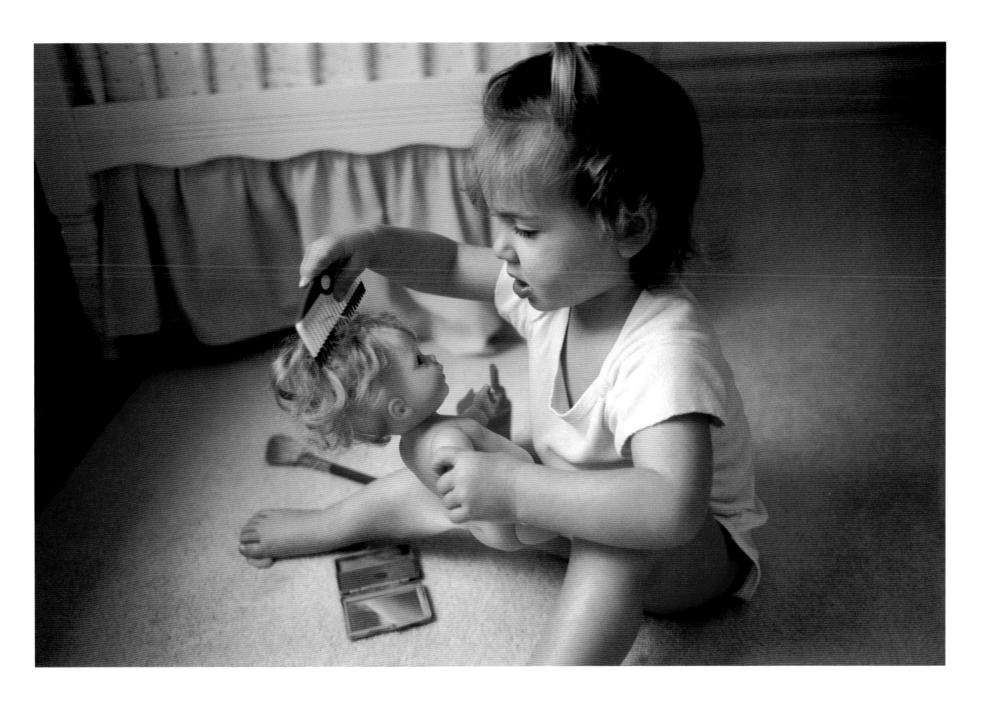

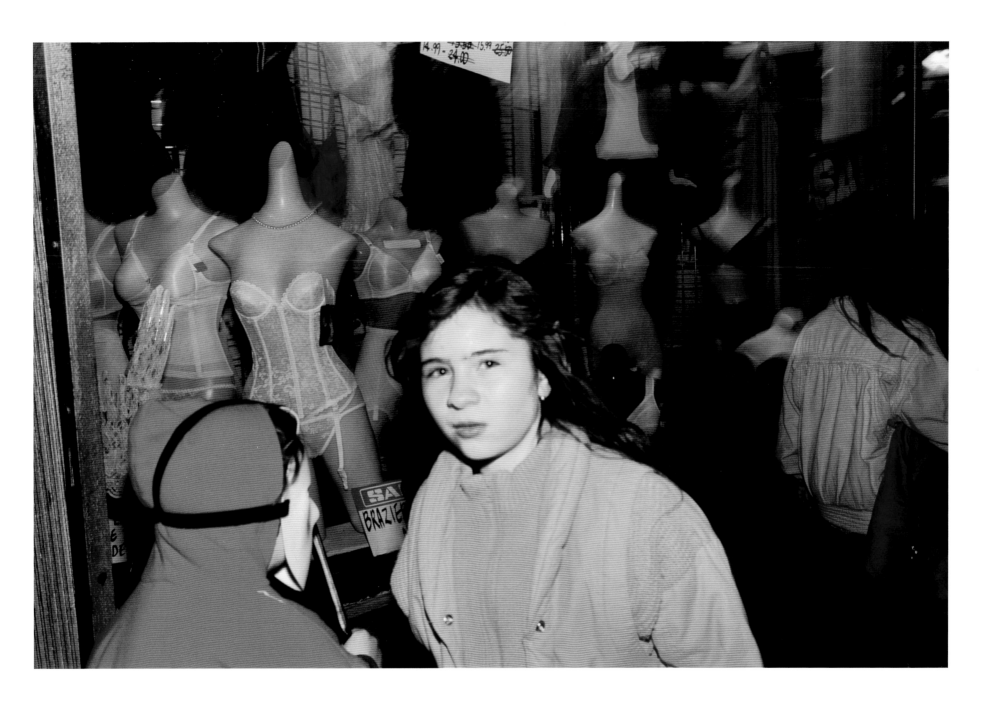

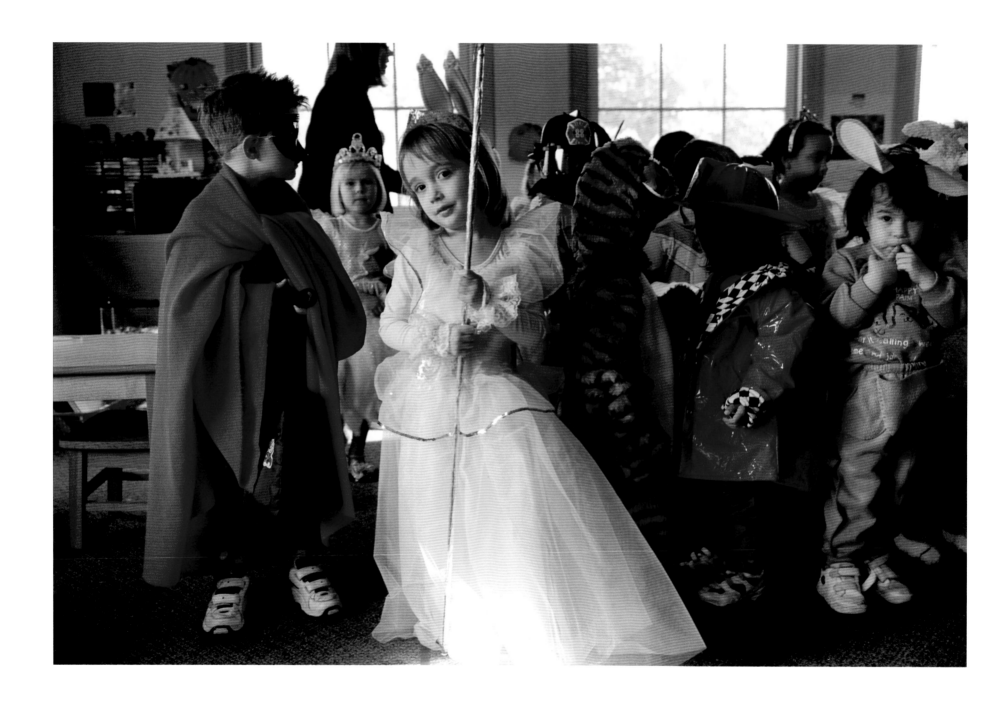

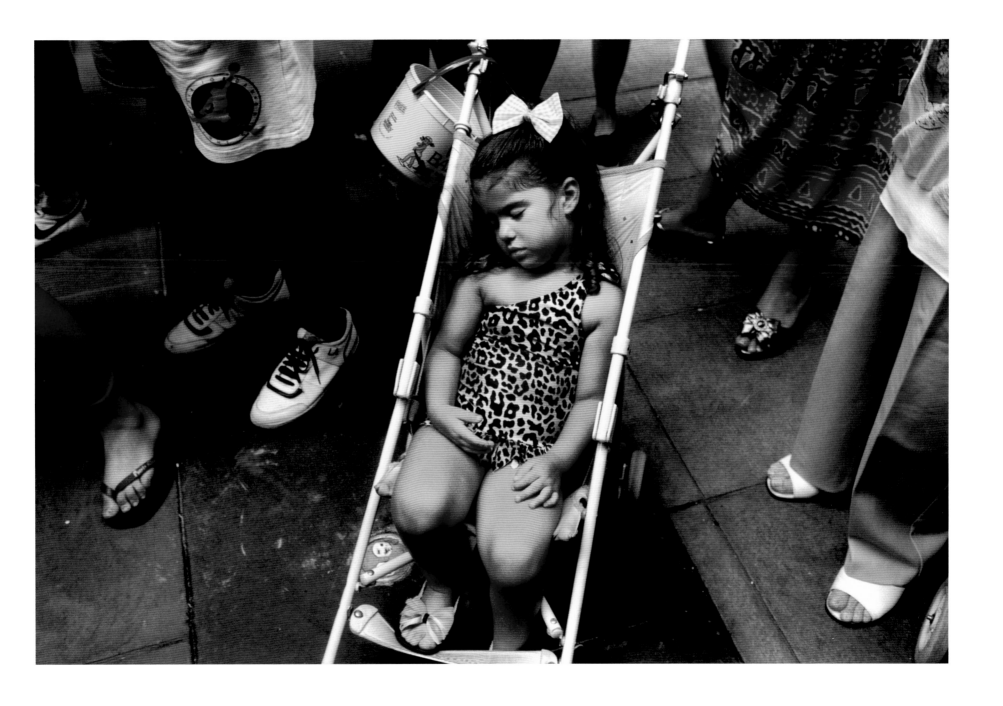

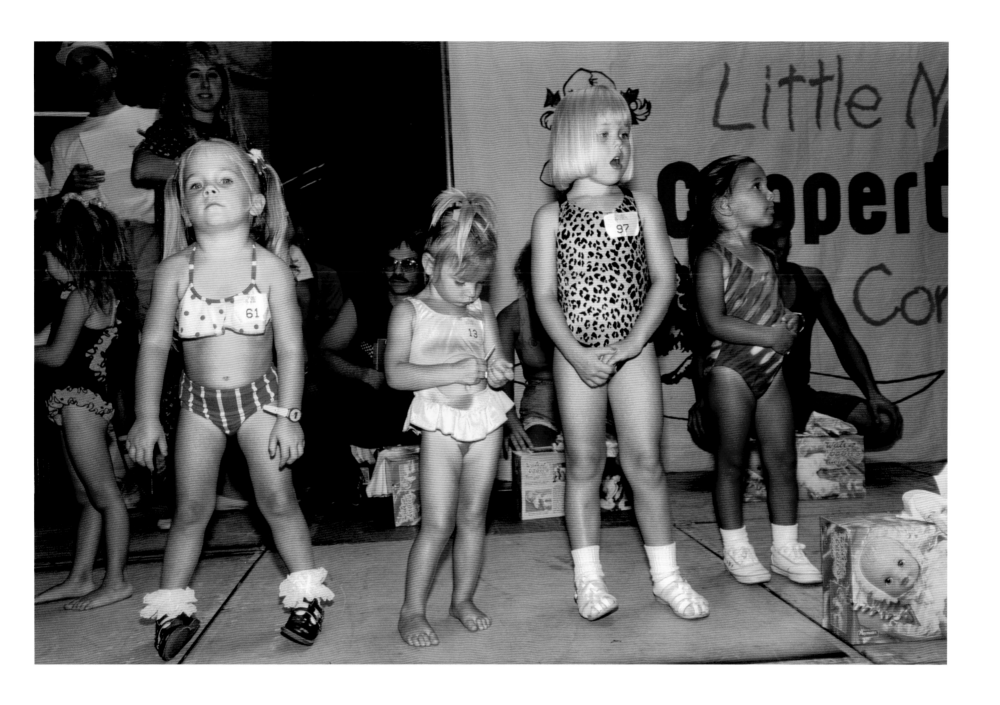

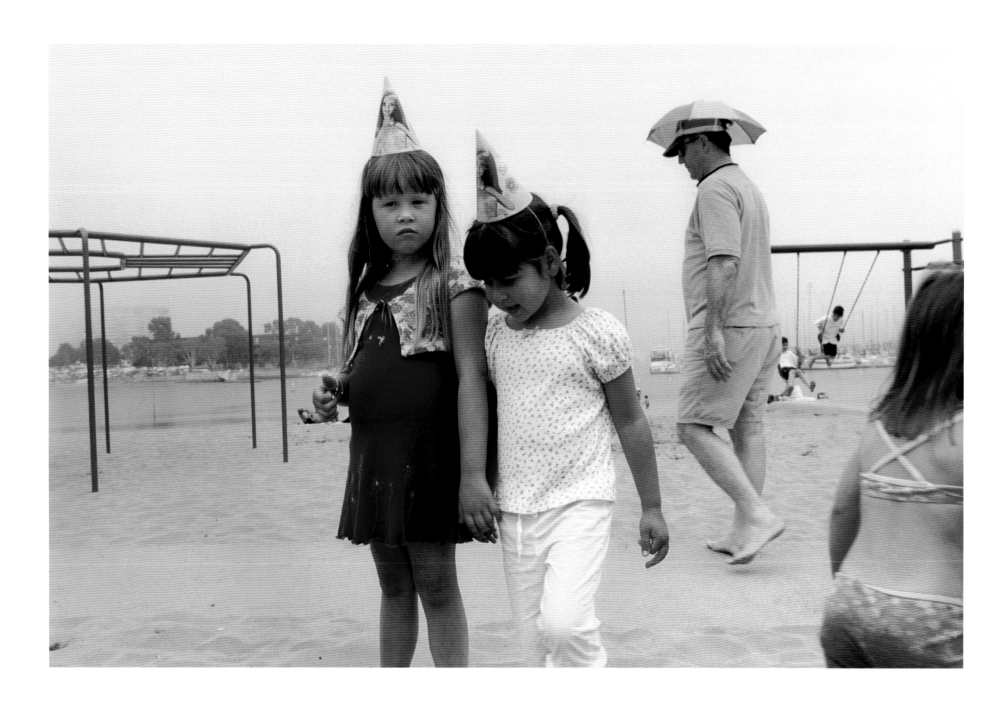

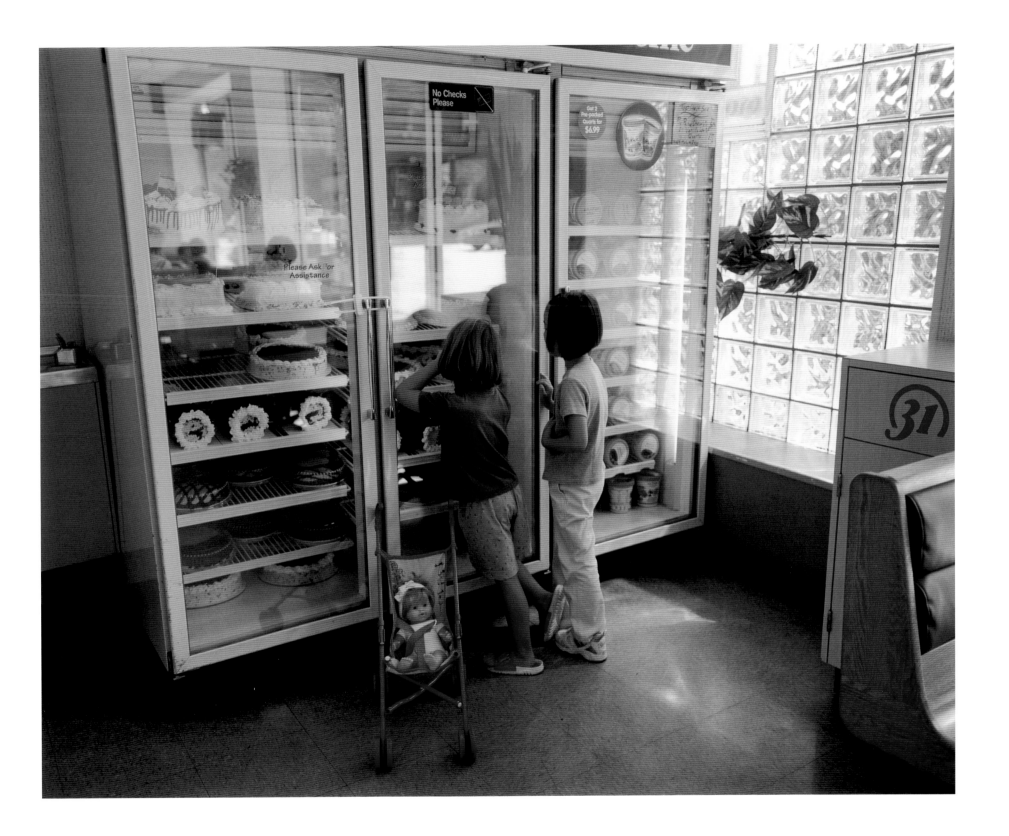

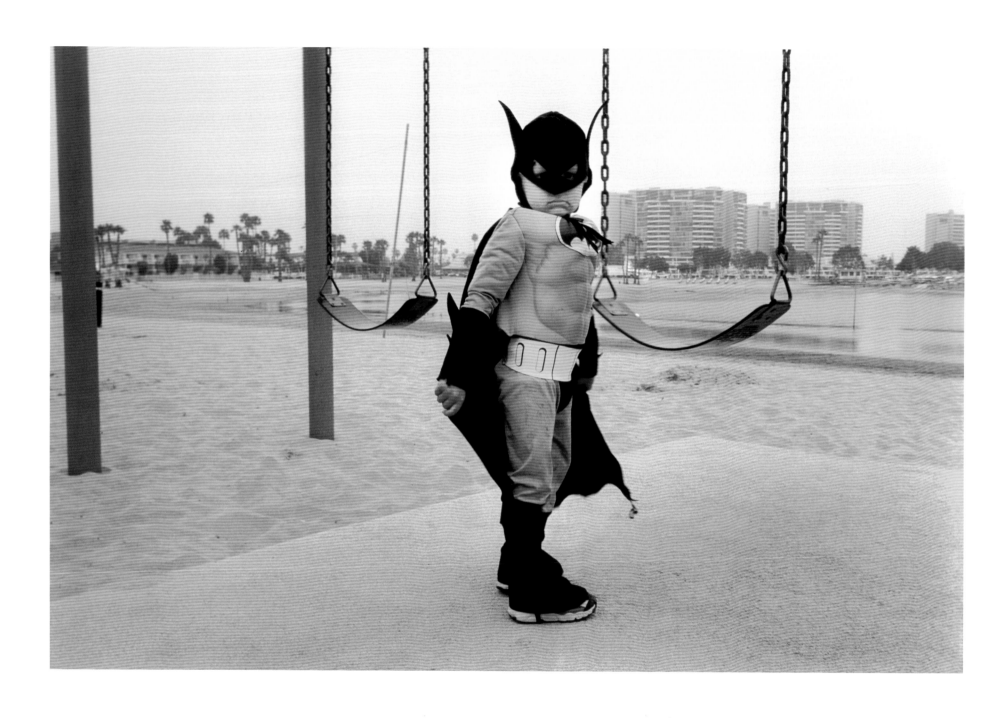

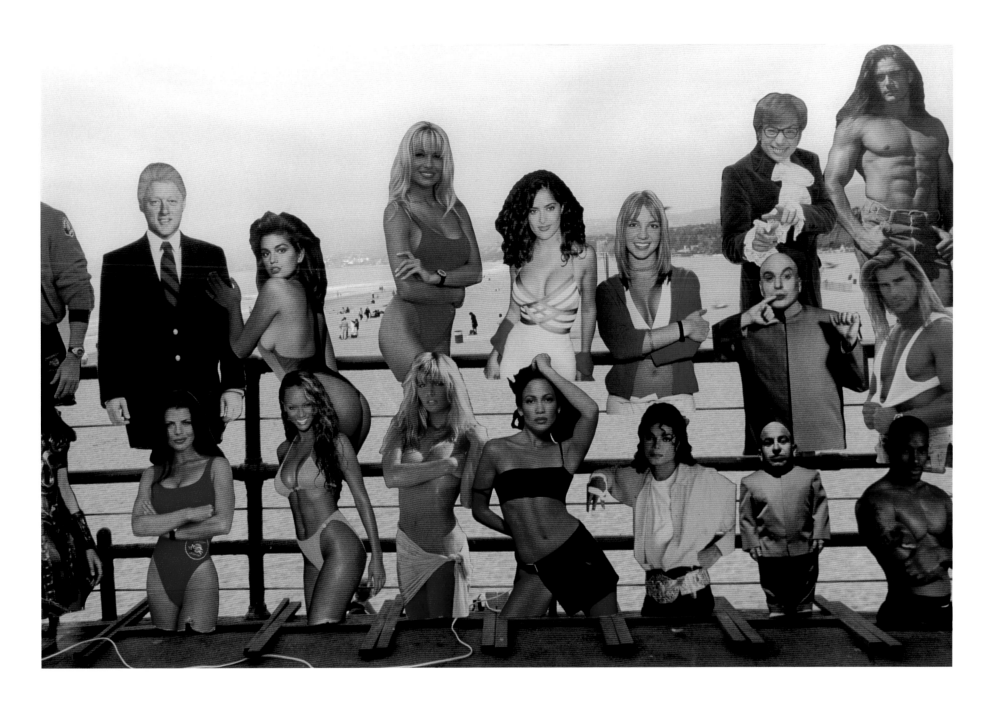

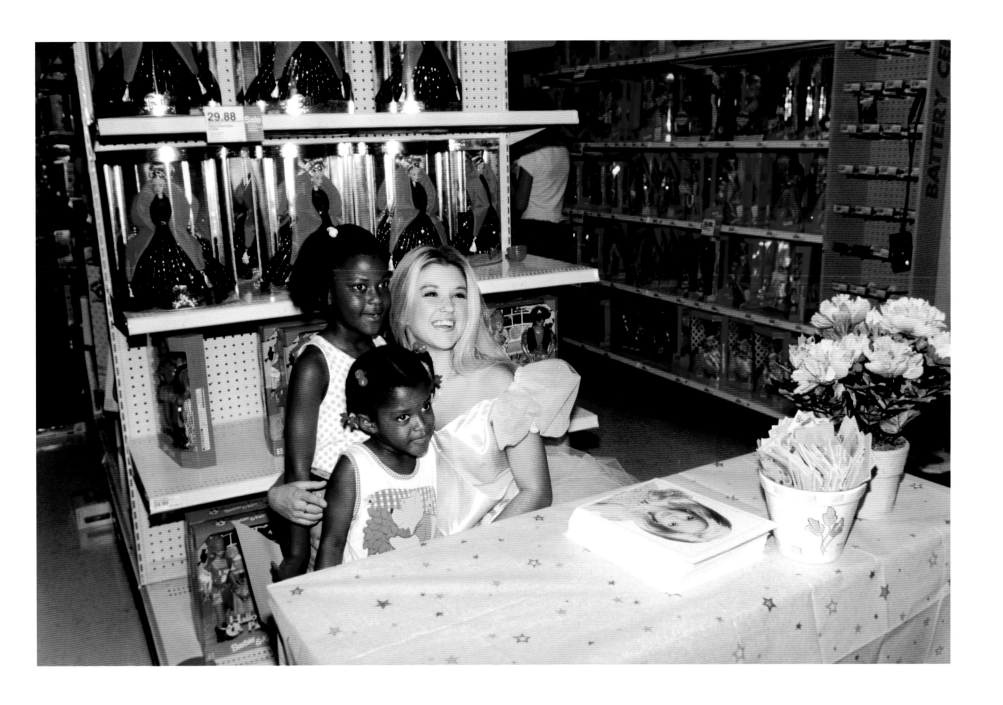

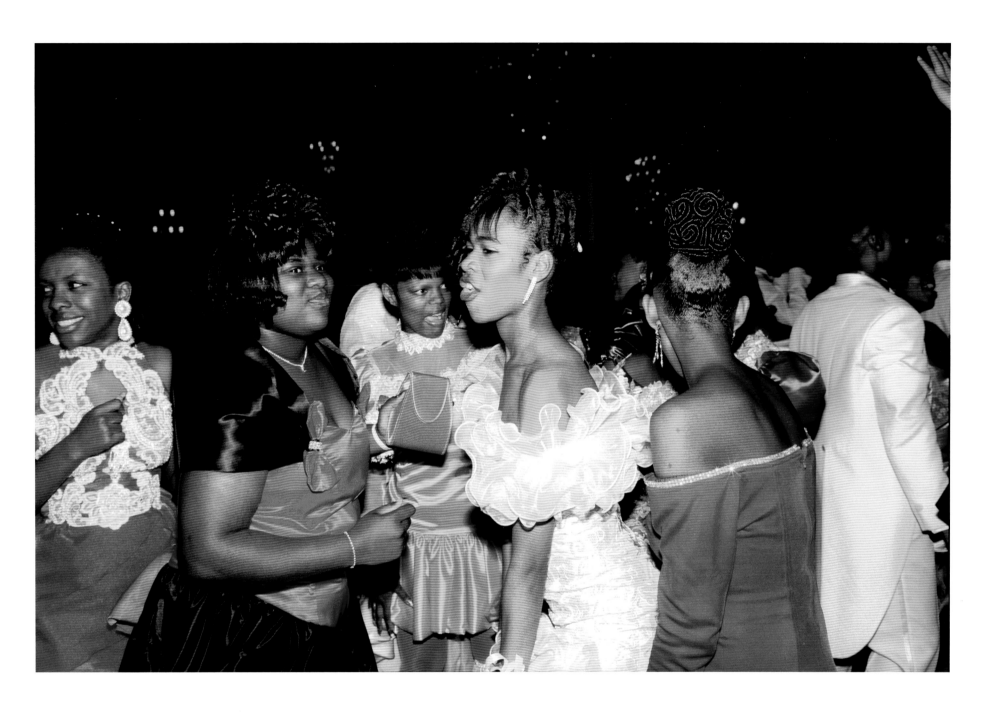

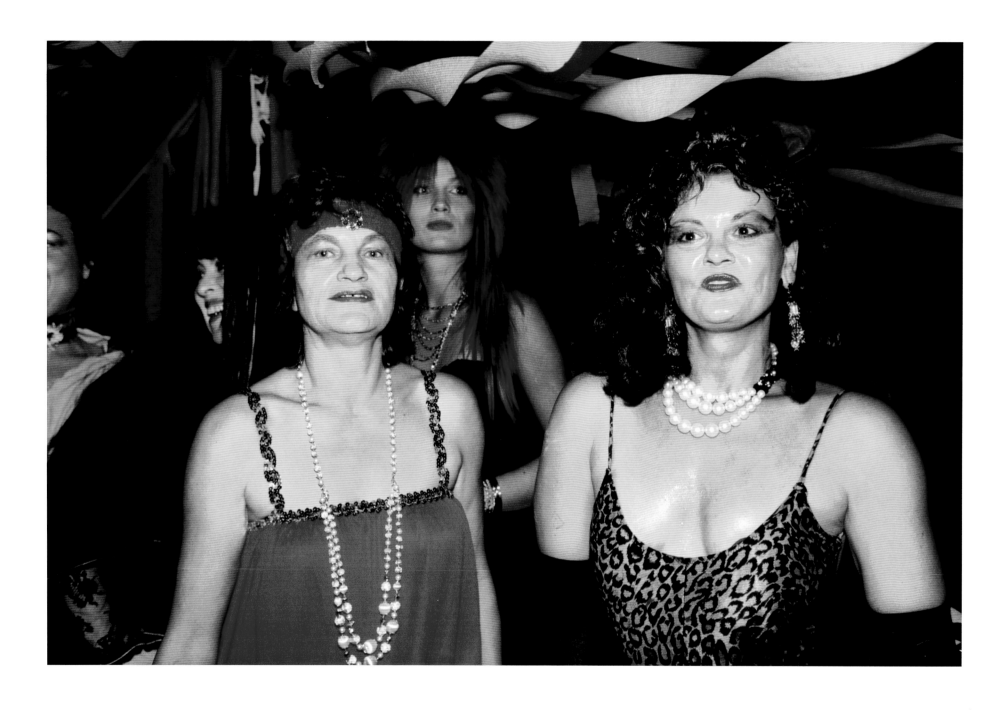

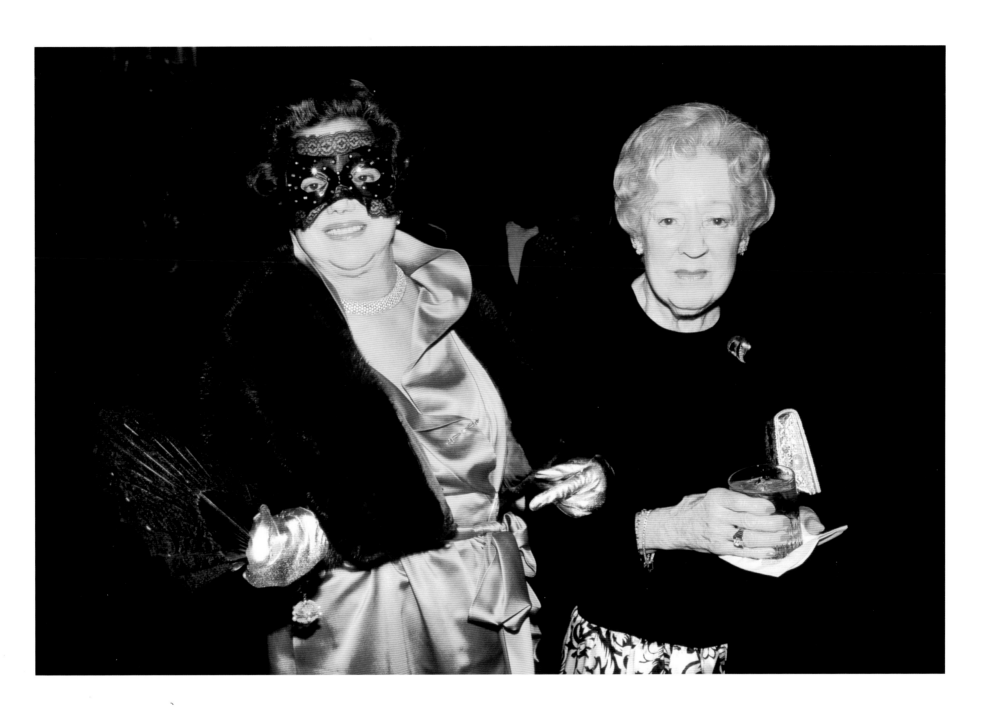

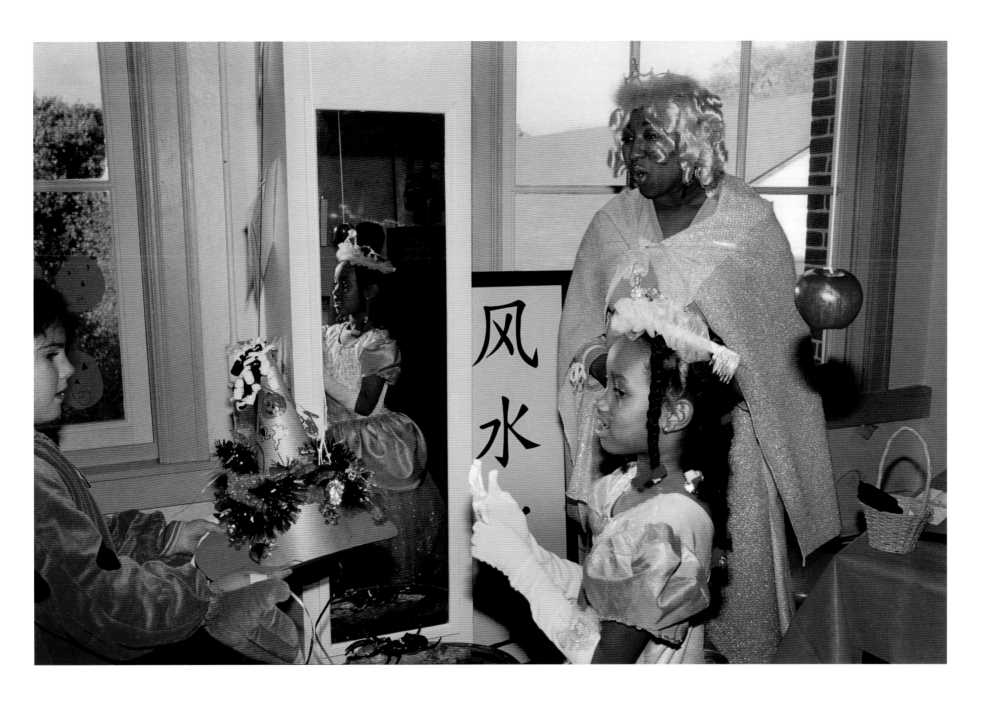

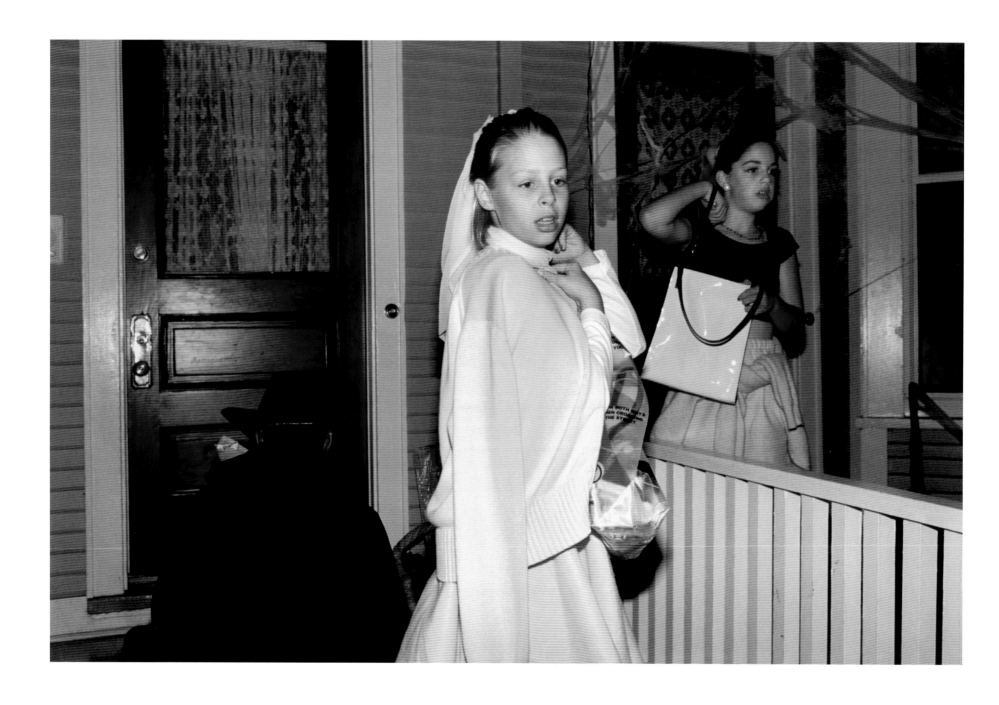

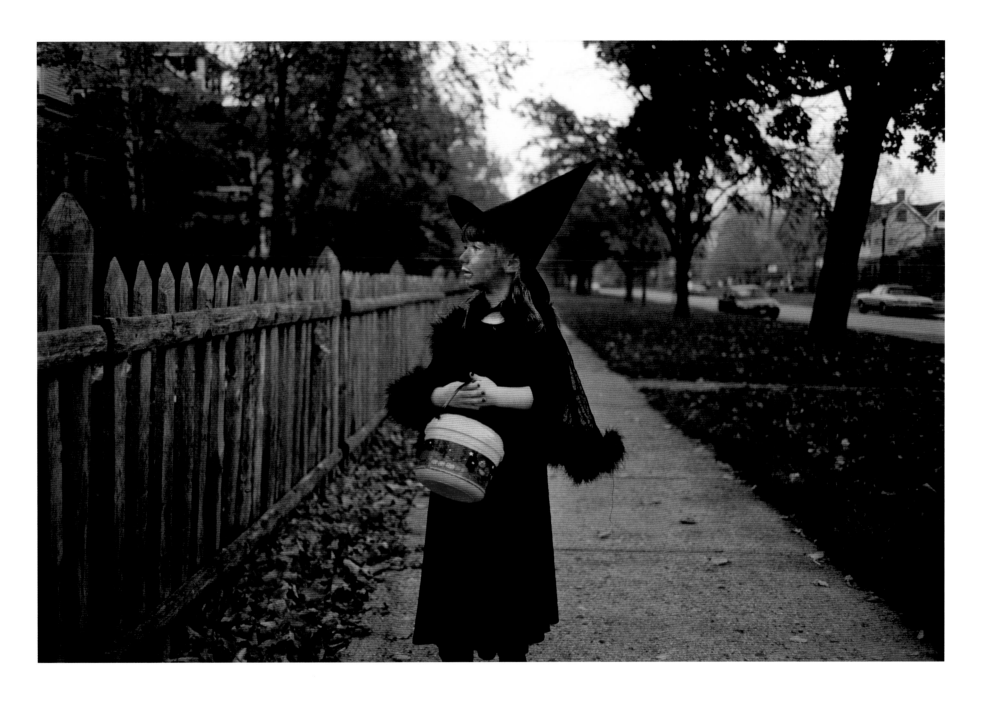

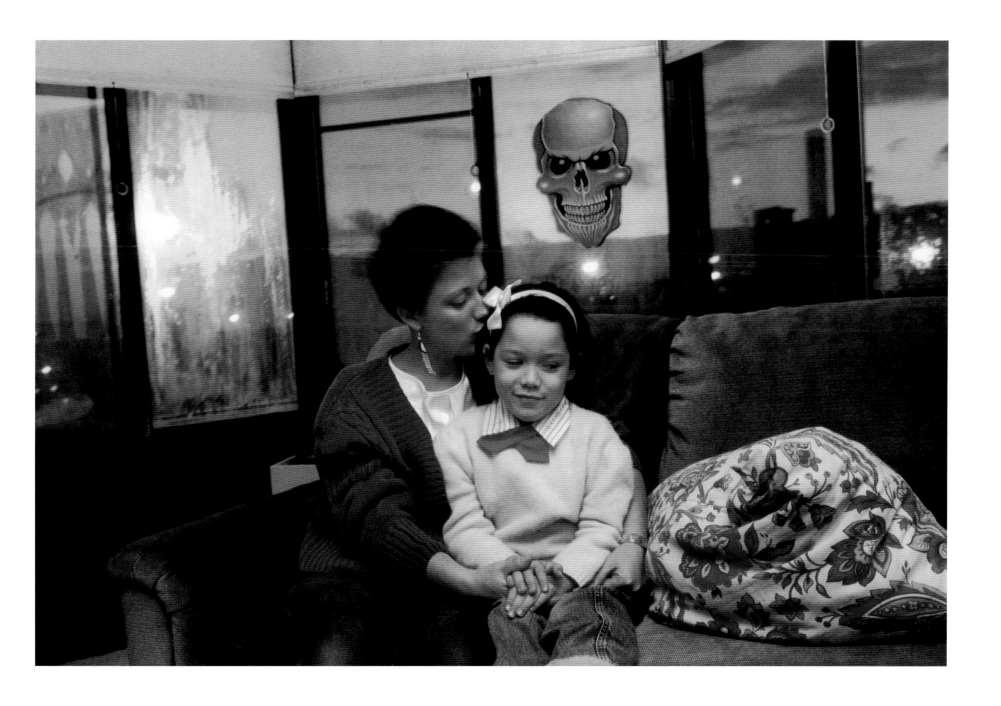

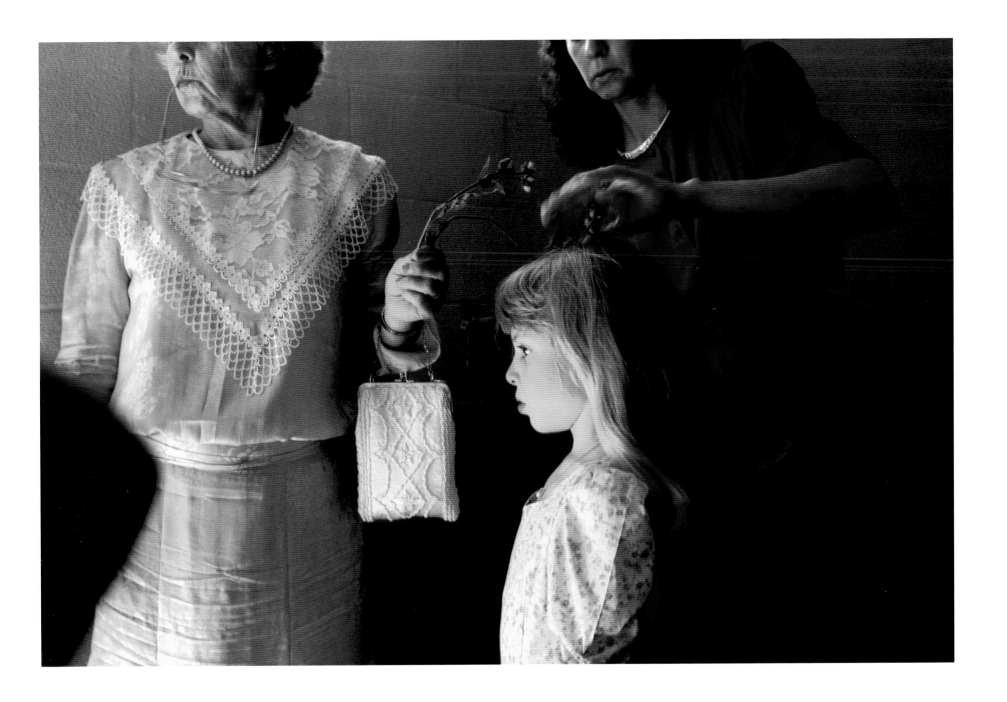

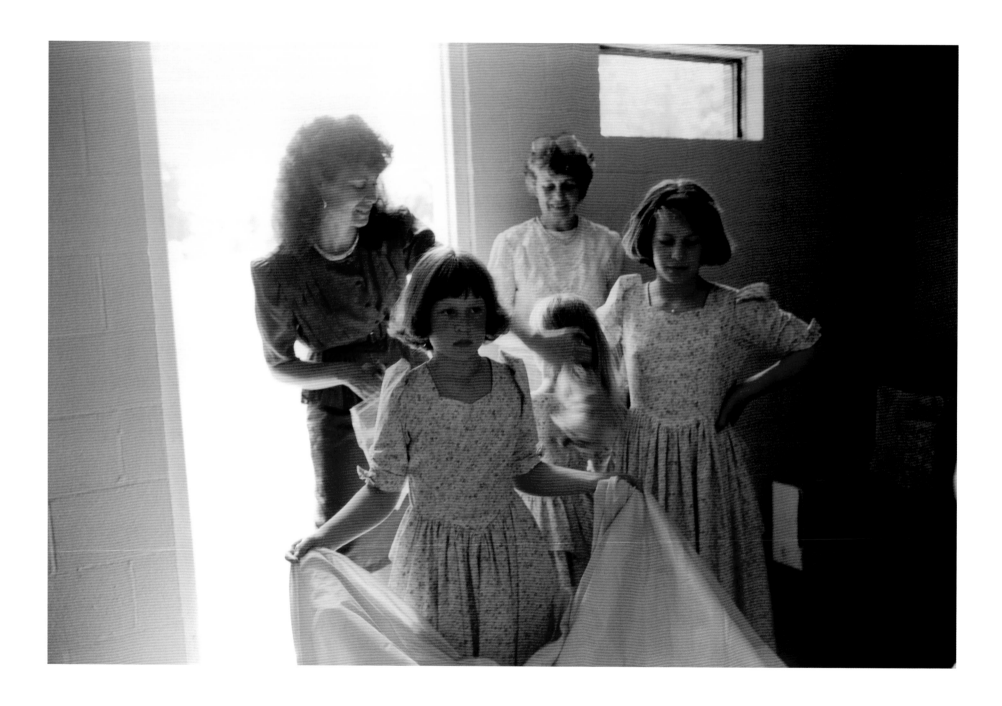

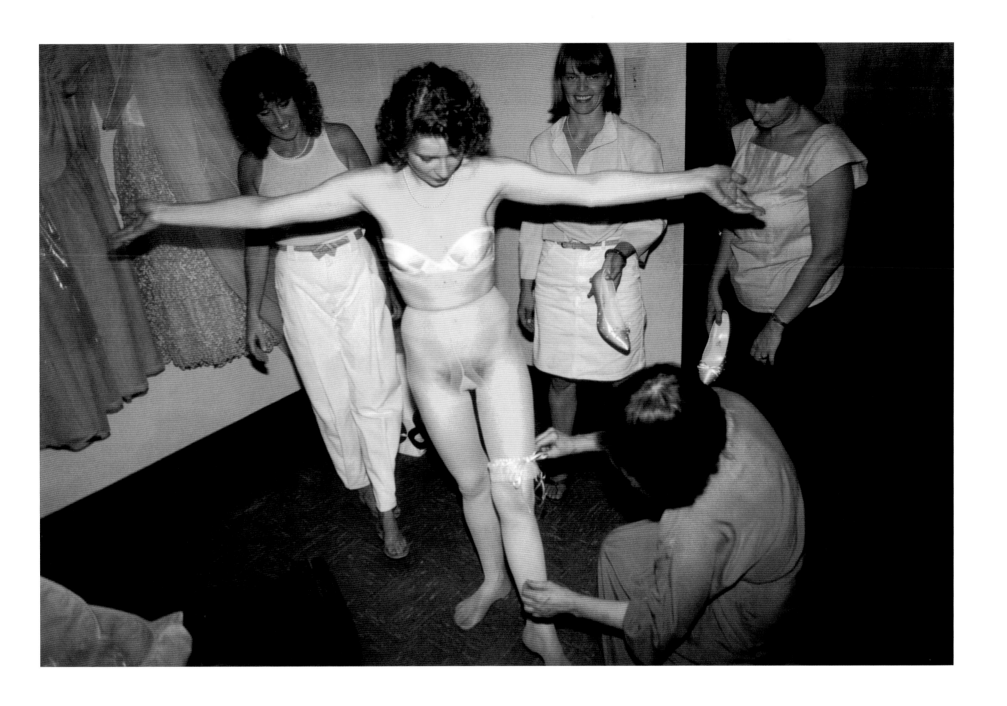

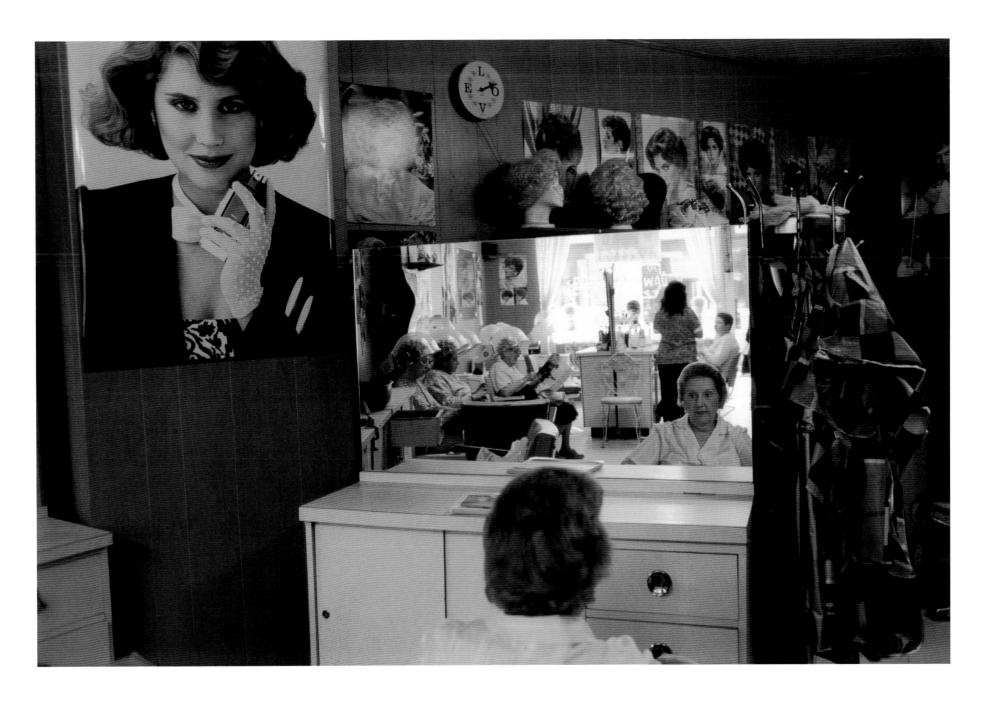

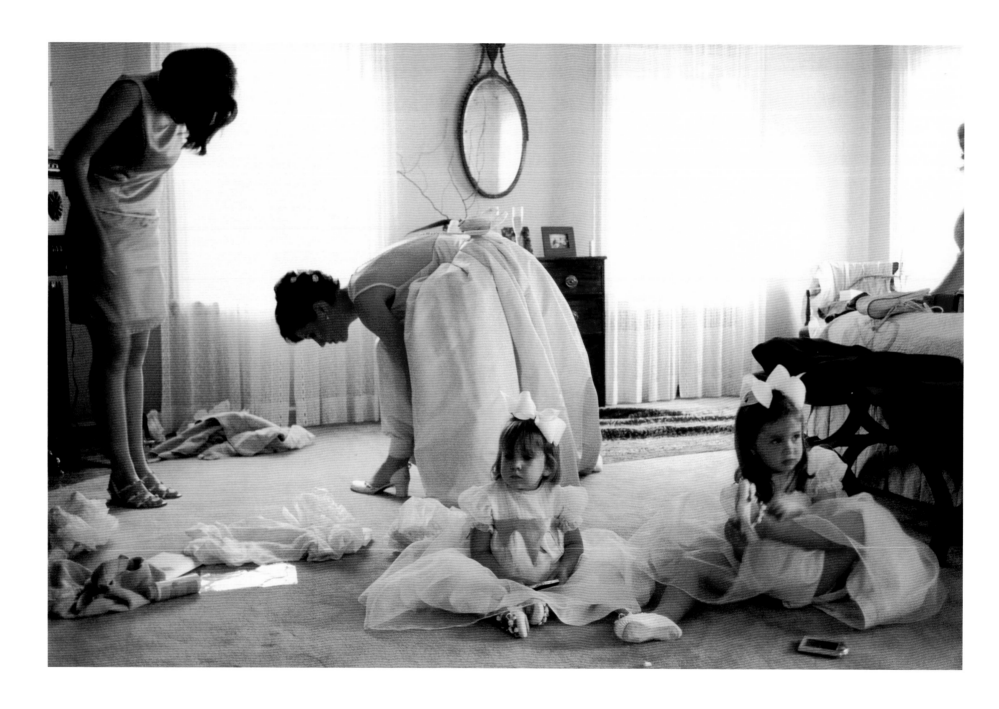

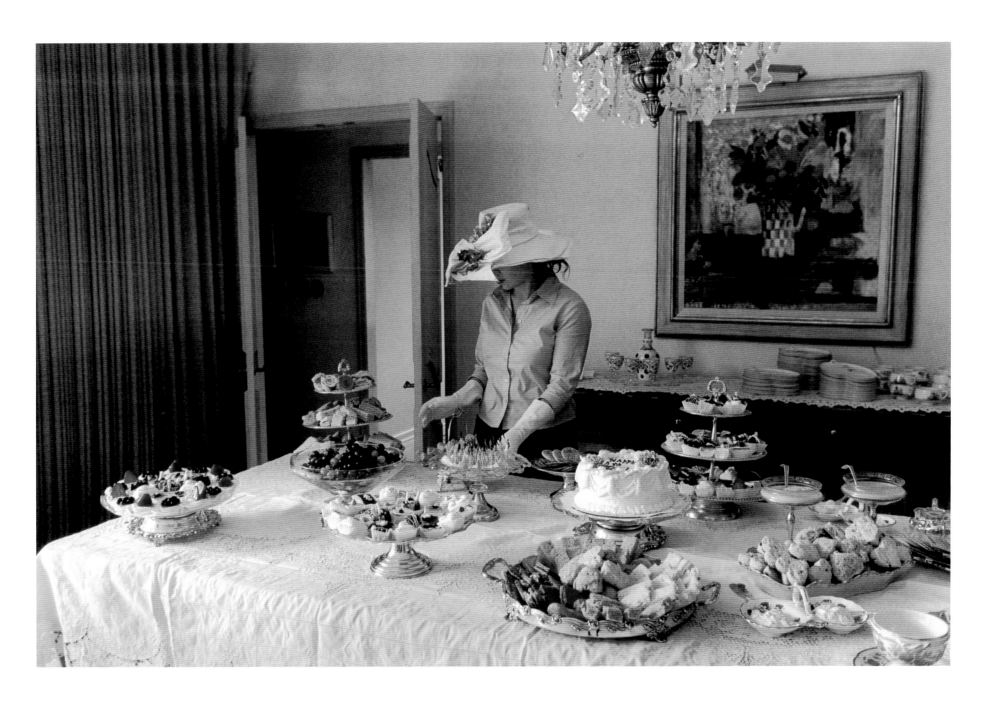

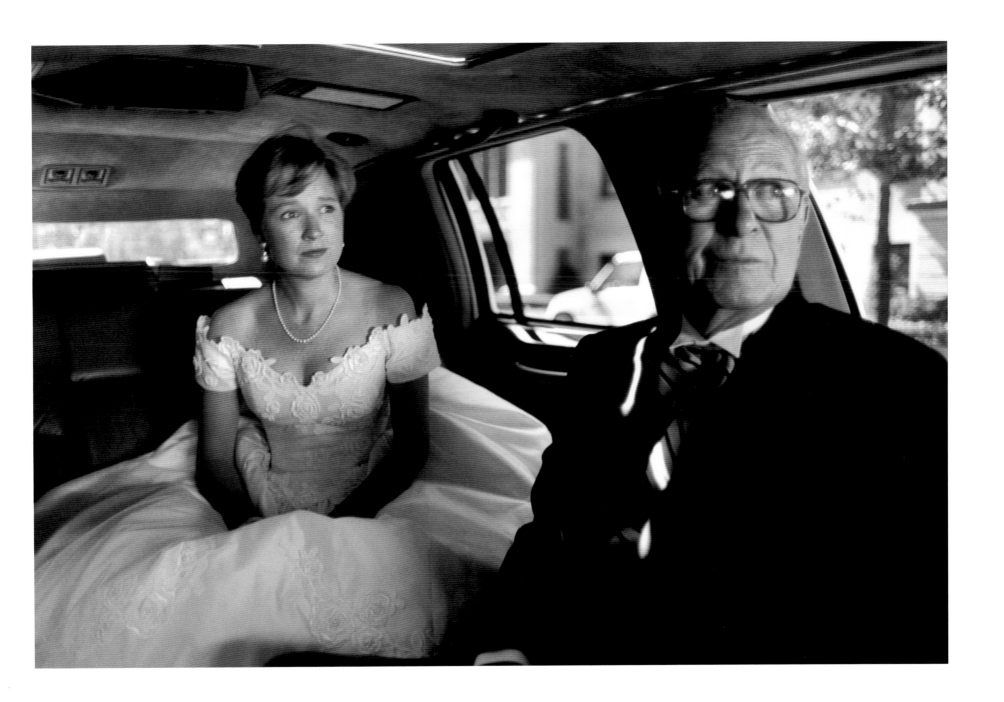

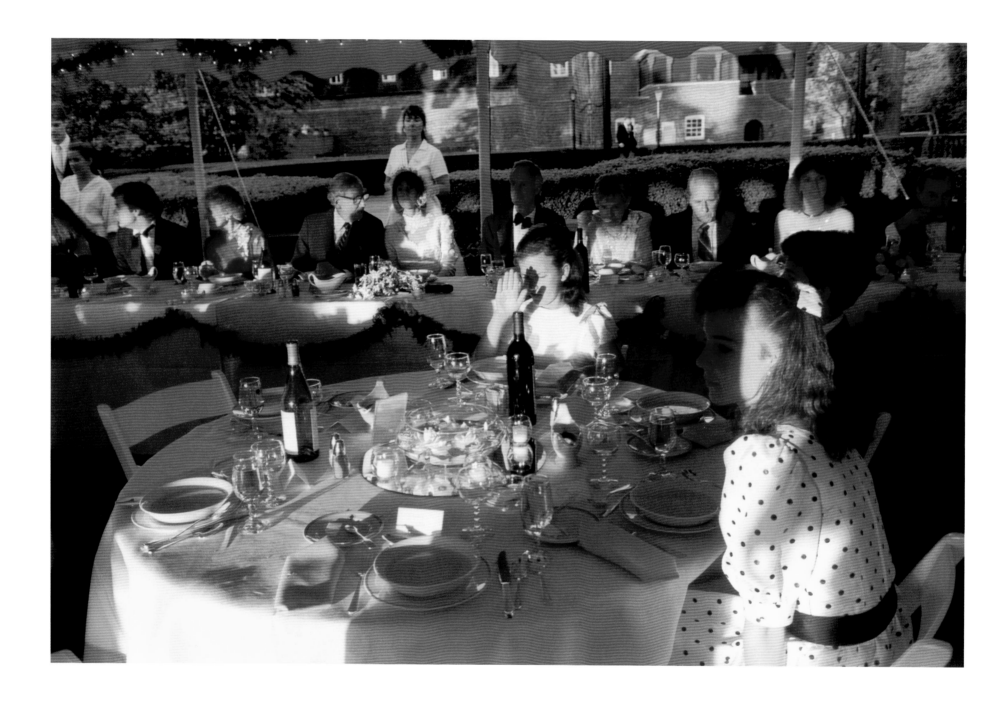

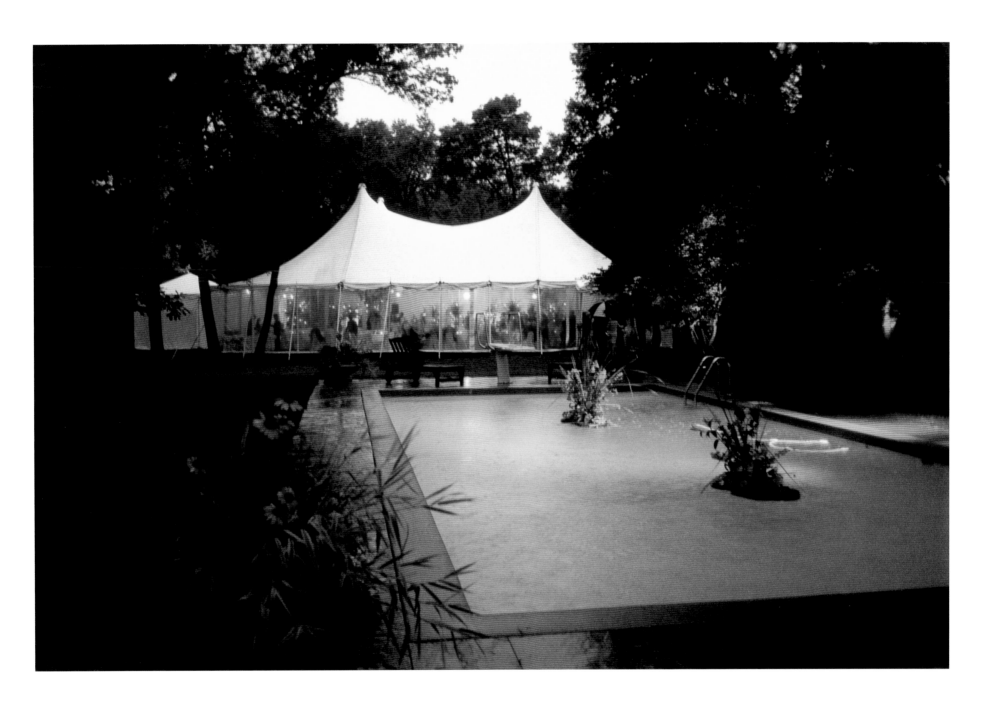

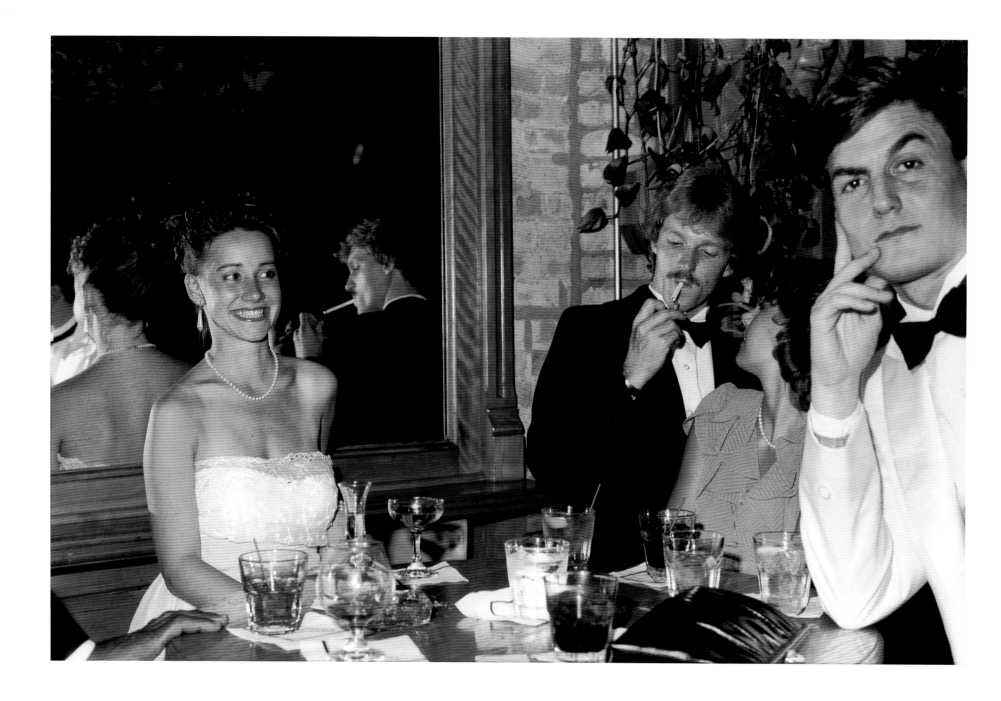

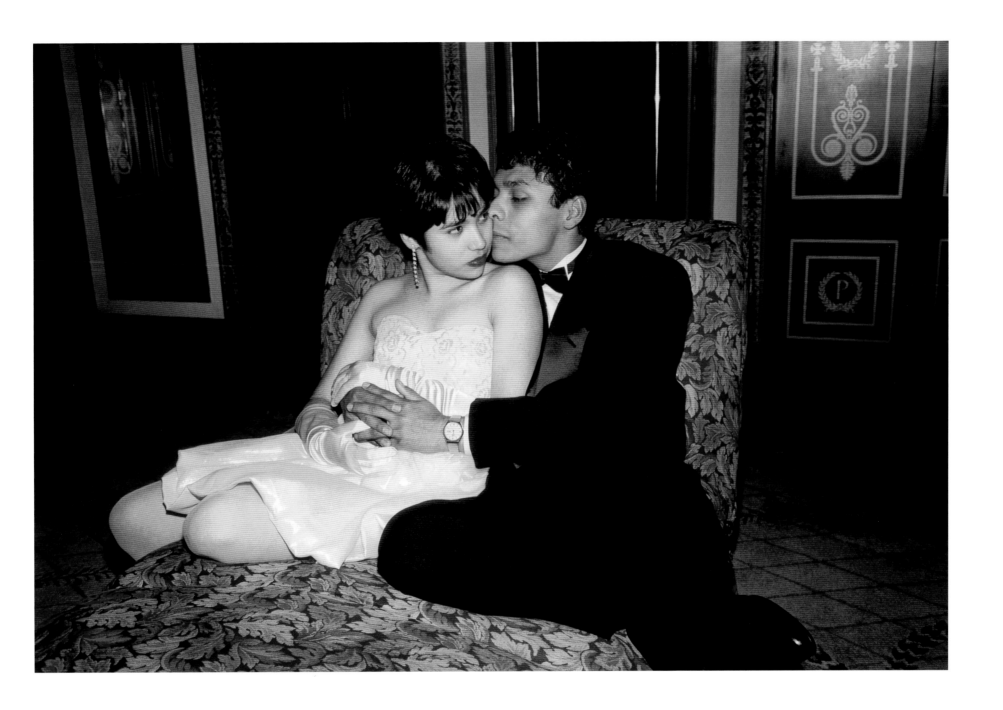

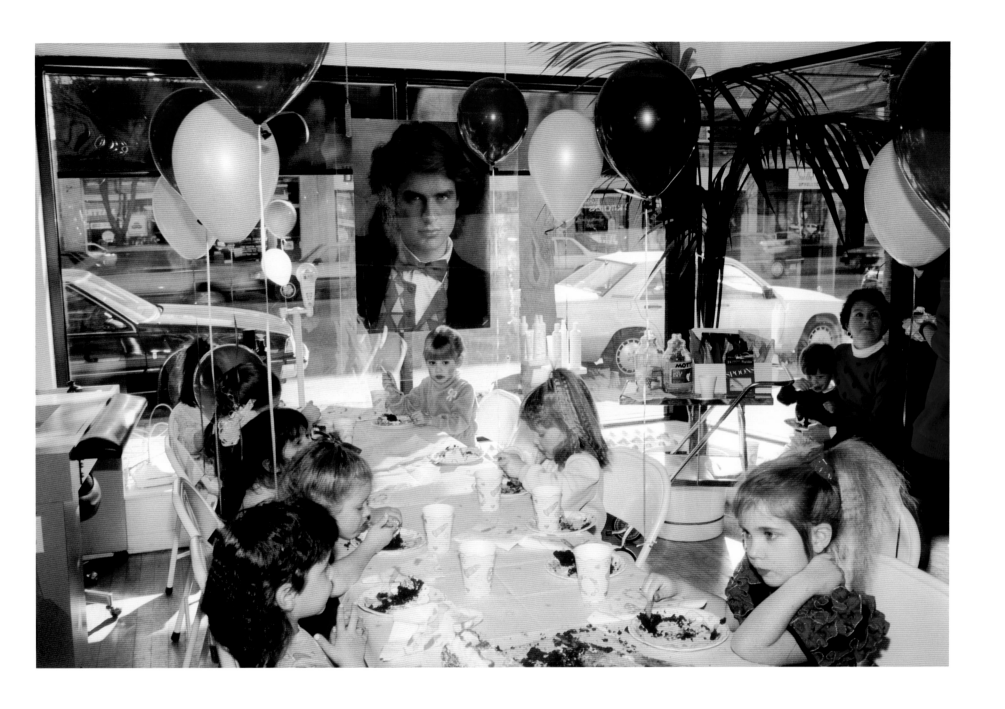

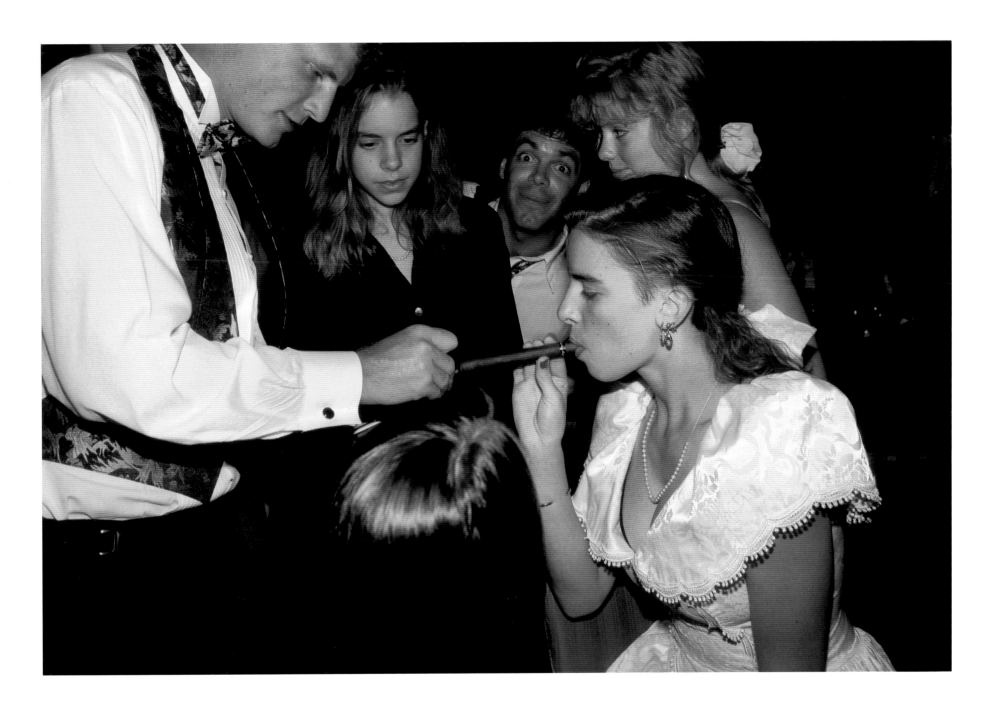

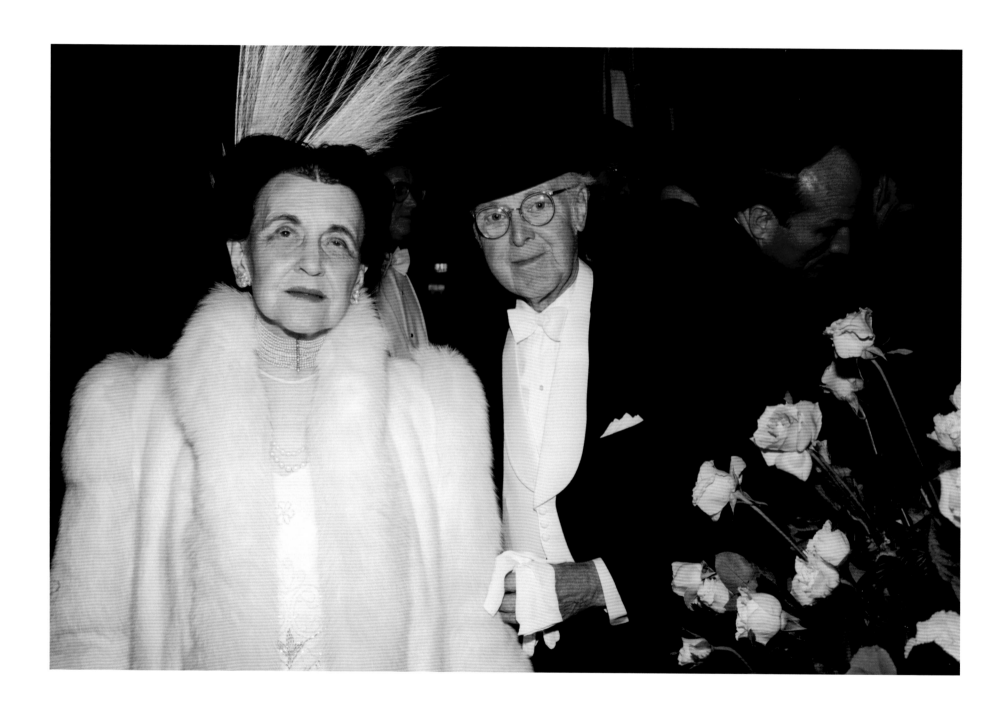

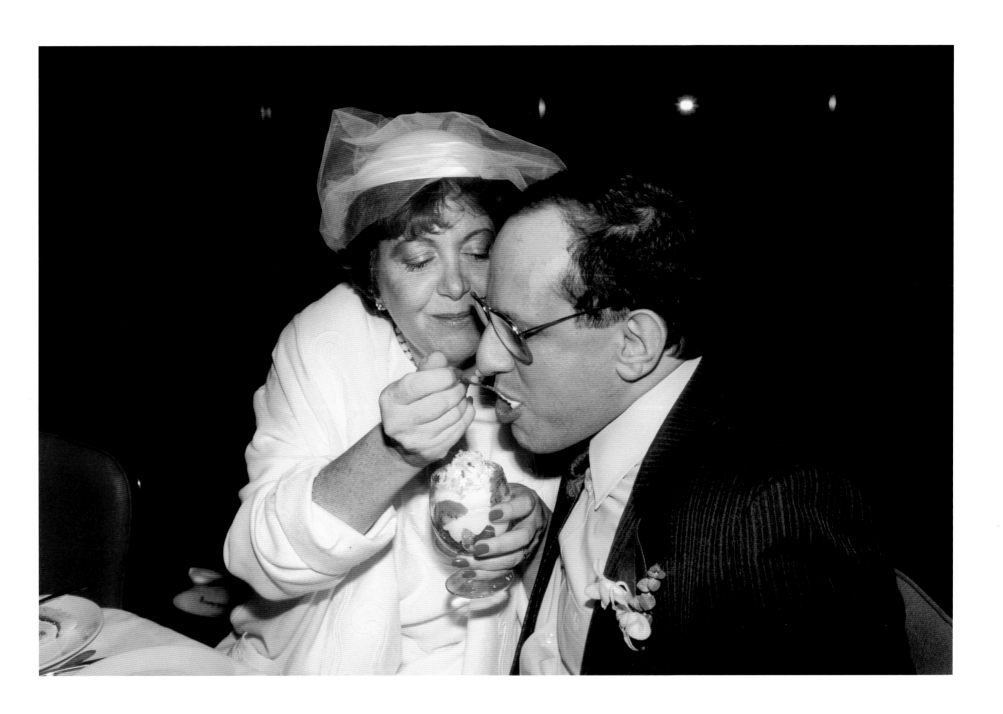

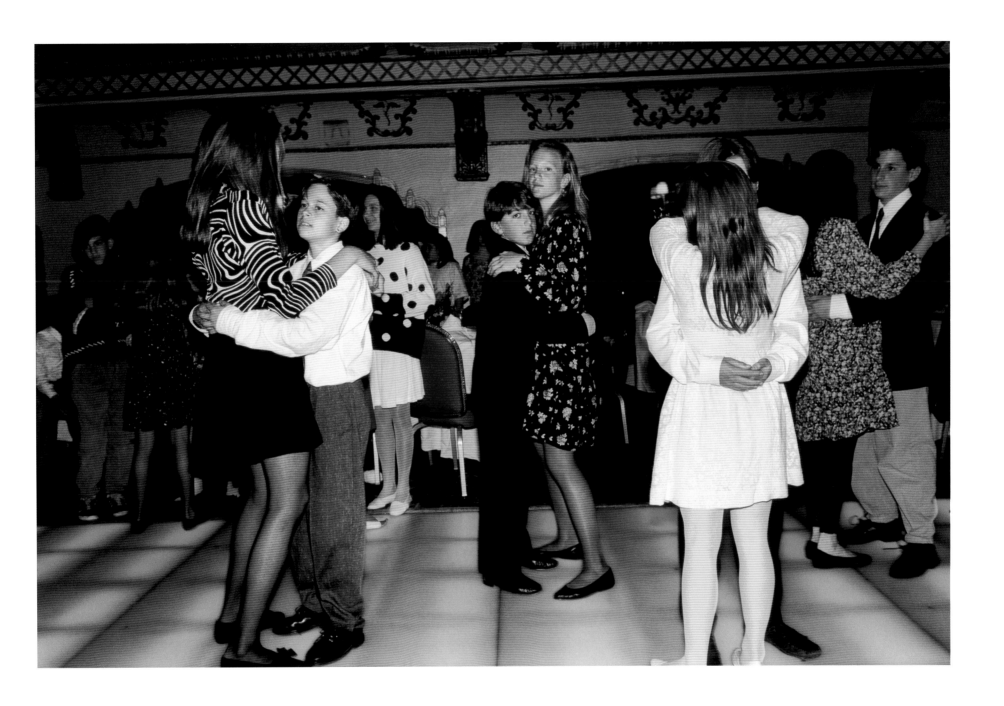

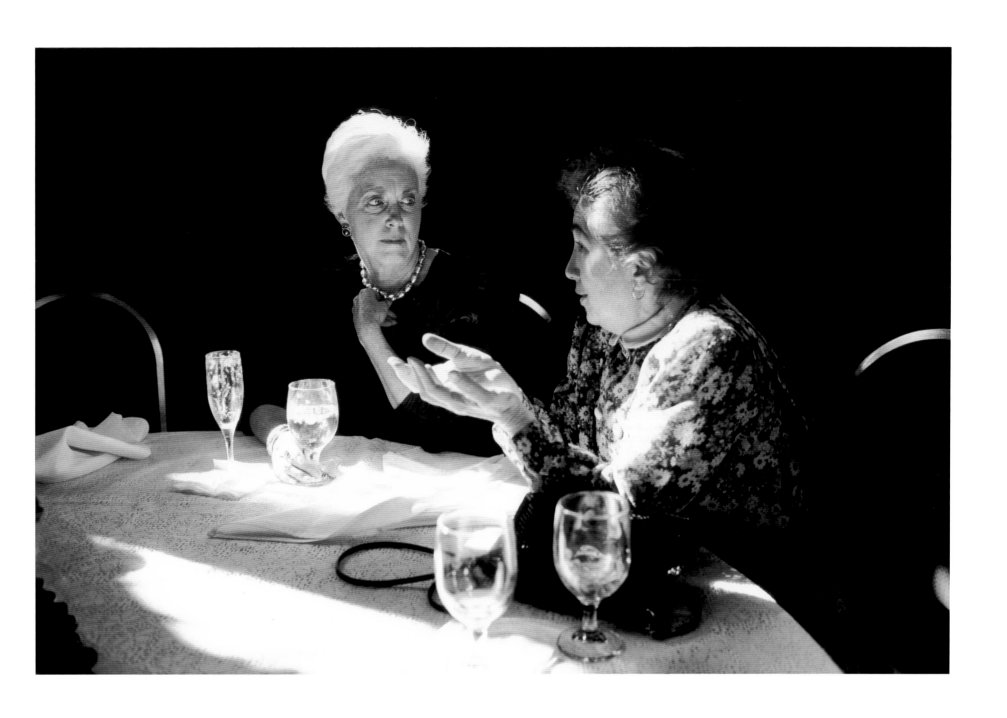

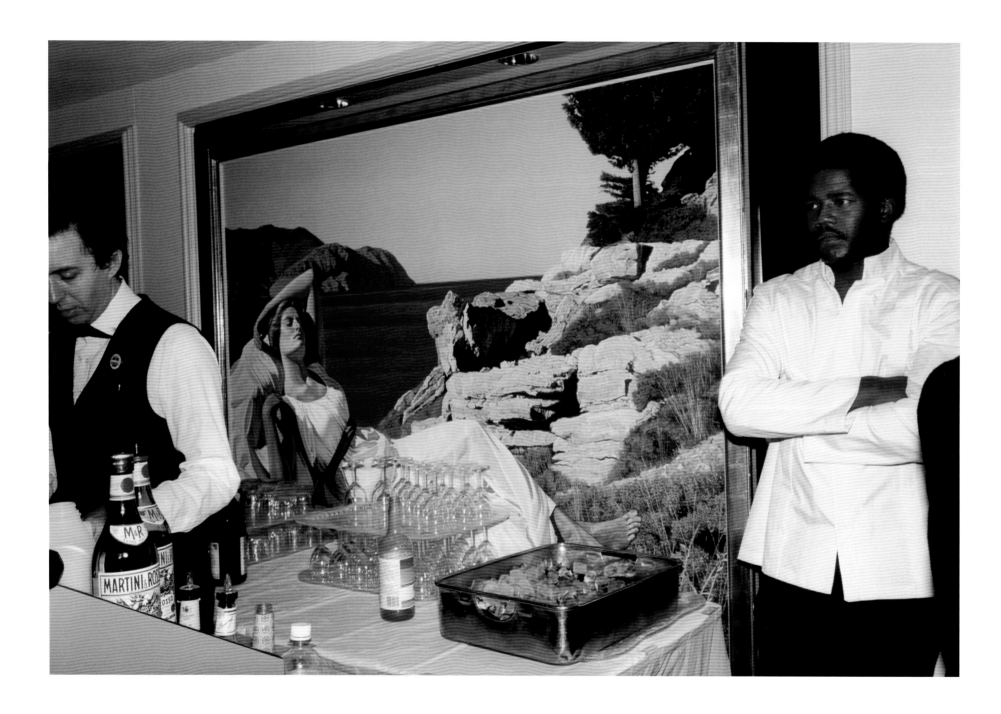

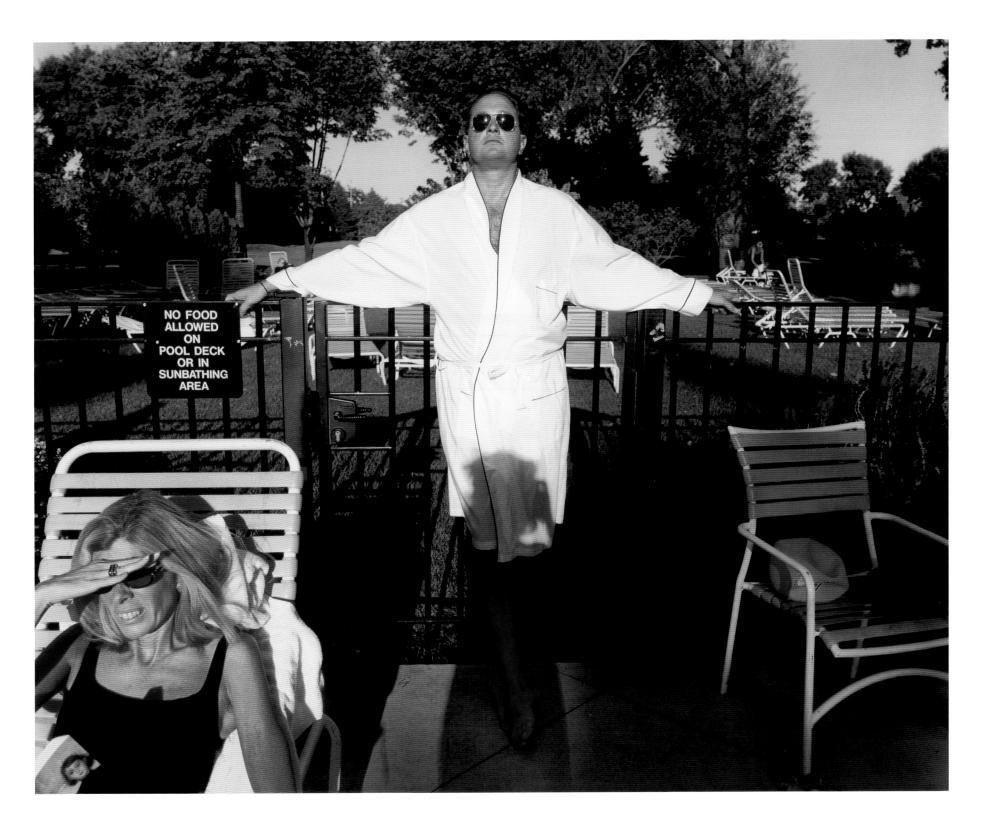

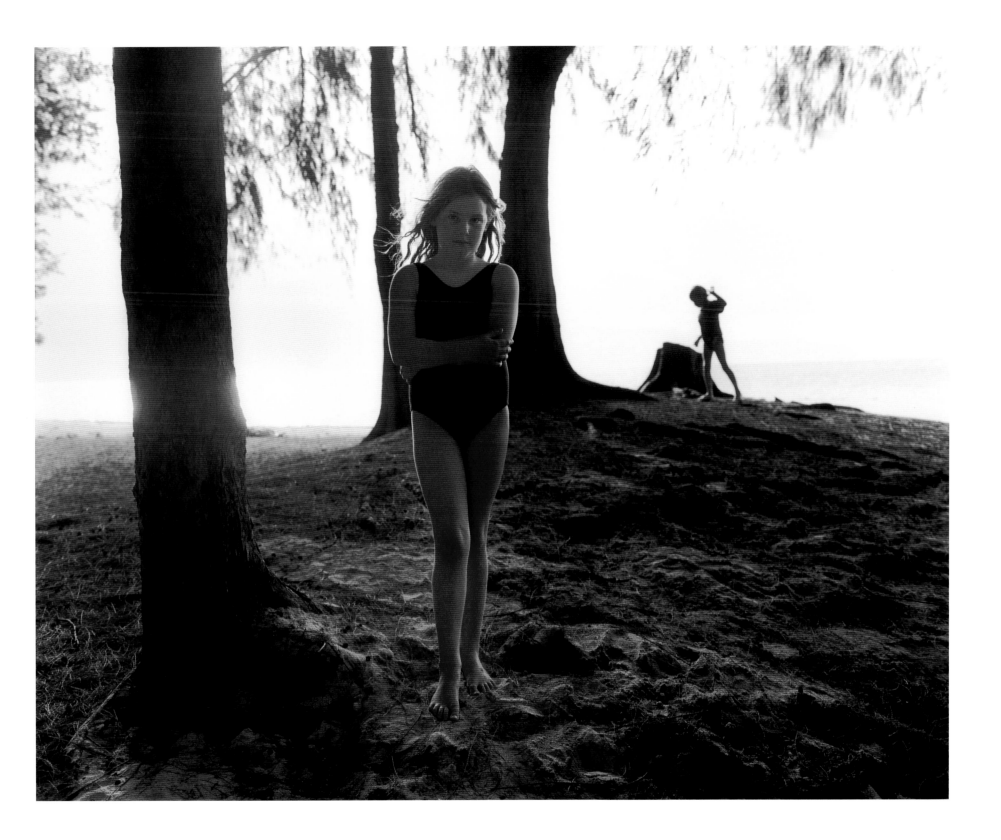

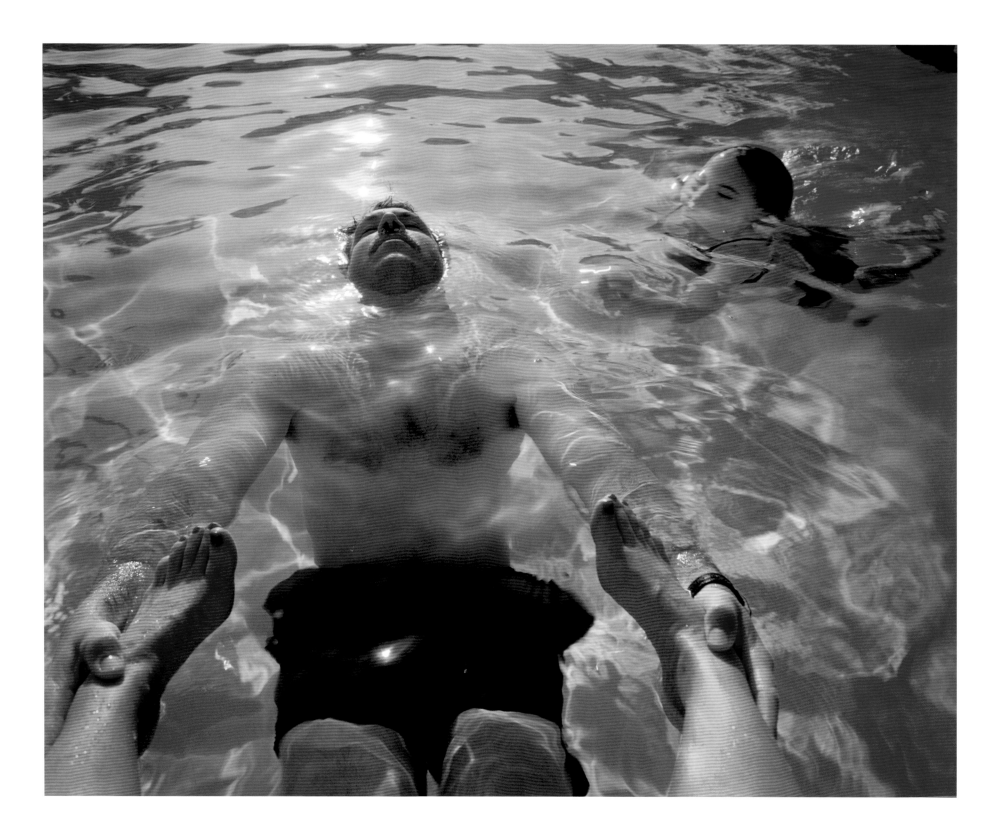

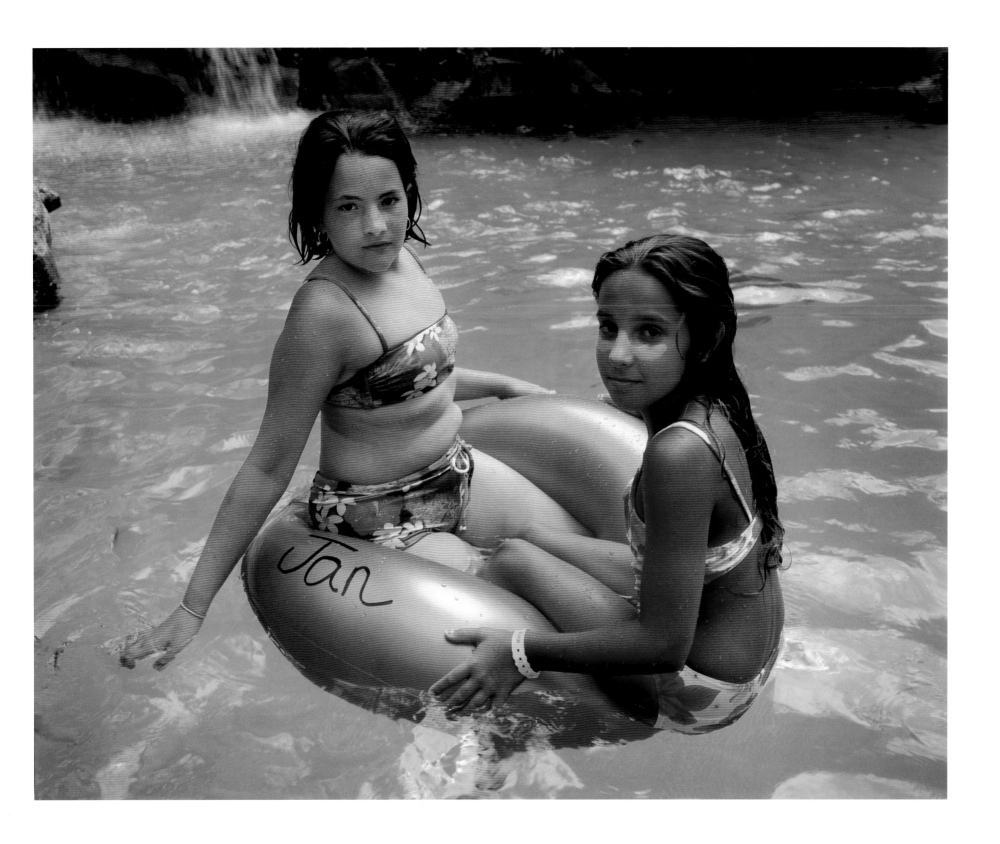

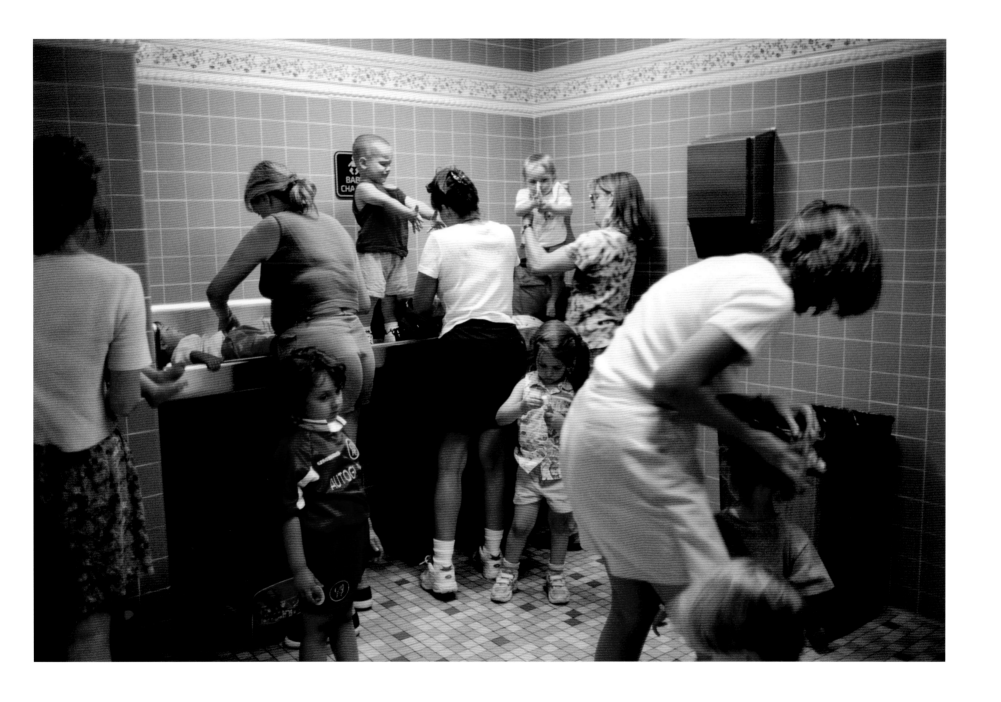

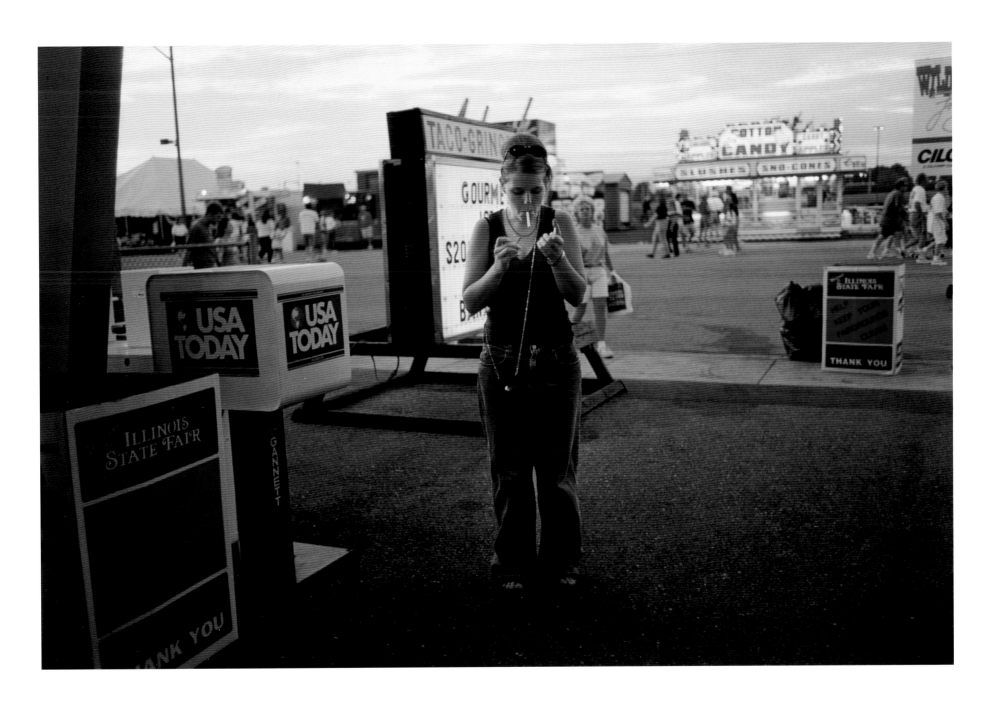

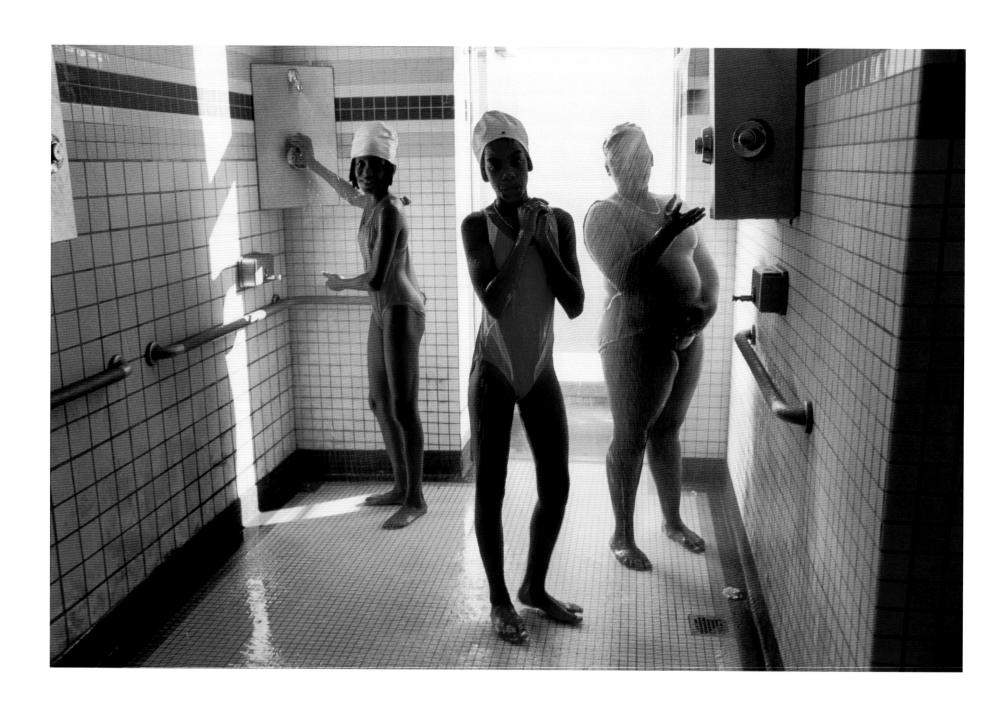

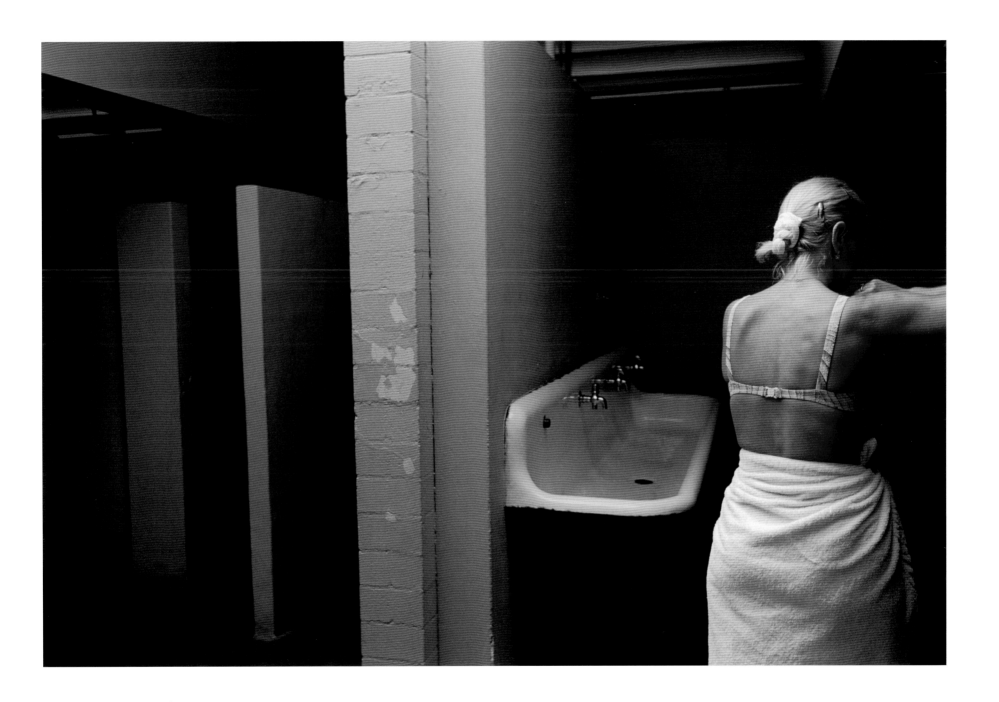

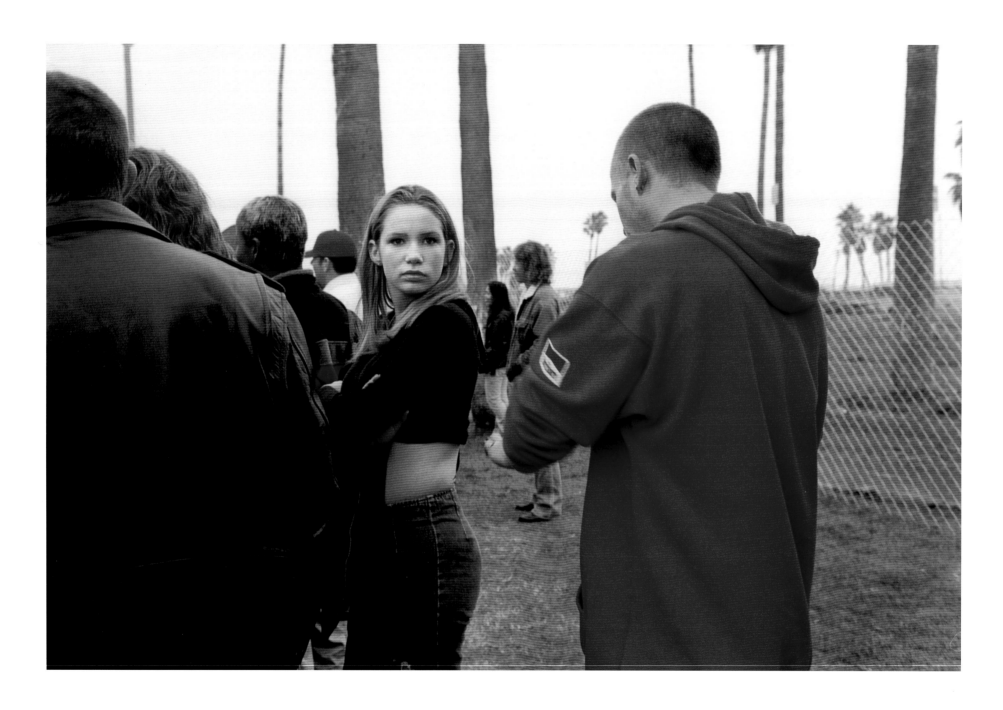

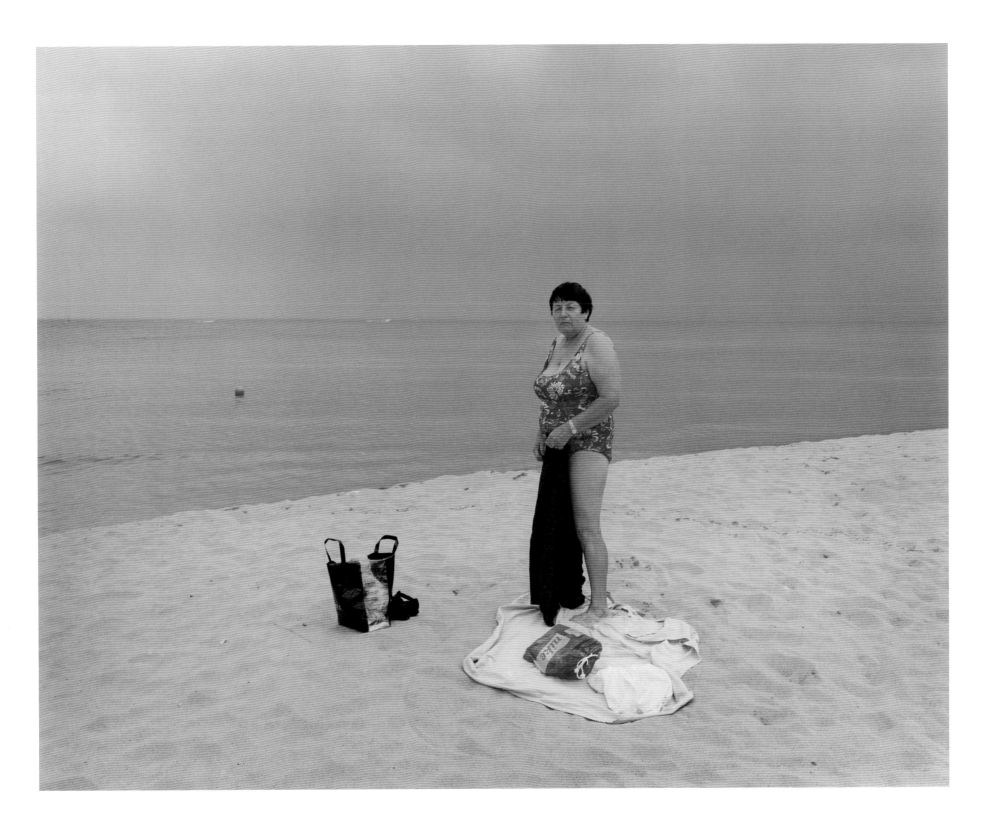

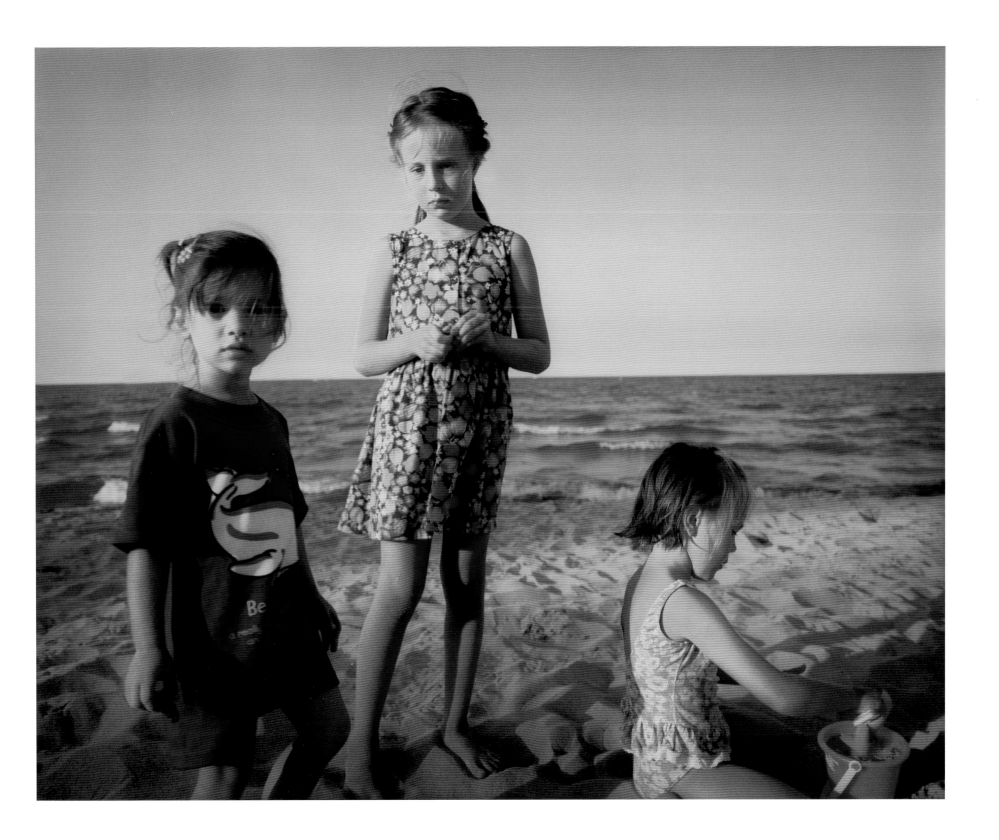

List of Plates

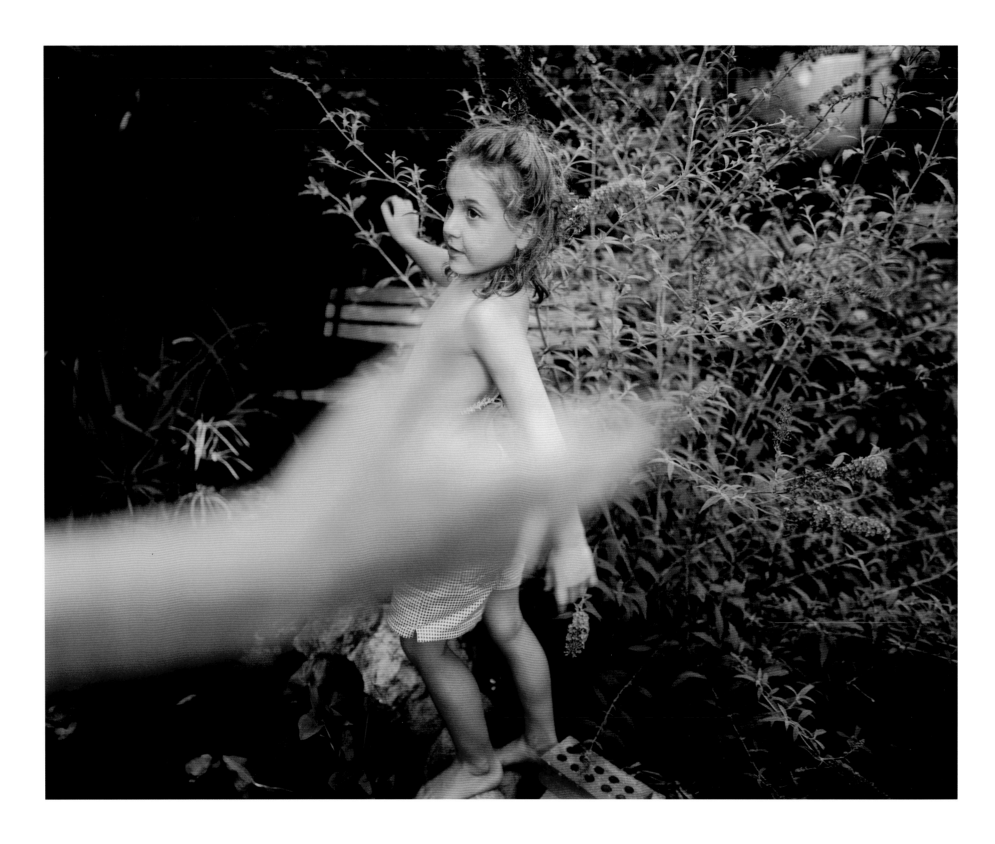

Acknowledgments

I wish to thank Bob Thall for all the ways he worked to bring this book to publication. Bob's encouragement and support aided my efforts through the long process of making a book. Bob also introduced me to his publisher, George F. Thompson, president of the Center for American Places. I am most grateful to George for seeing the forest when I could still only see the trees, for his skill in creating a sequence that most clearly elucidates the meaning of the pictures, and for his steady belief in the book. Ann Patchett's foreword was an unexpectedly generous gift. I am moved by the depth of Ann's understanding, her compassion, and the beauty of her language.

I am privileged to have had Peter Bacon Hales as a friend since I began this body of work. A brilliant teacher and photographer, Peter helped edit countless piles of photographs with insight and honesty. The John Simon Guggenheim Memorial Foundation Fellowship I received in 1999 provided tremendous support when it was particularly welcome. At the Guggenheim Foundation, Joel Connaroe and T. Thomas Tanzelle were especially gracious and helpful. An advocate of my work since she first arrived in Chicago, Sarah Anne McNear's friendship, unfailing support, and counsel have been essential in putting this book together. I am grateful to Sarah for her many efforts on my behalf, not the least of which was introducing Richard Press to this project. Dick's commitment to photographers and enthusiasm for this project opened many doors for me. Richard and Jean Press and Ralph and Nancy Segal generously stepped forward to provide the primary financial support for the book. Their generosity truly made this book a reality. Thanks go also to Jack Jaffe for his funding of the *Changing Chicago* project in 1987, where this work first began, and to Jack and his wife Naomi Stern for their support of *Regarding Emma*. Other long-time friends and donors I wish to thank are Mary Williams, Michael Lenehan, and Robert Roth.

I am grateful to Peter Galassi, Sandra S. Phillips, Anne W. Tucker, and Denise Miller for their support early on. Thanks to Catherine Evans for including my work in *The View from Here*. Catherine's enthusiasm and friendship are always appreciated. I am indebted to Sylvia Wolf for her continuing support and astute guidance. David Travis and Elizabeth Siegel offered encouragement and thoughtful advice. My deepest gratitude goes to devoted friends who have been advisors, trusted critics, and confidants: Kate Friedman, Karen Buckley, Cindy Horowitz, David Ives, Maxine Henryson, Maxine Friedman, Marcy VanderTuig, Ruby Rochetto, and Eileen Madden. I am indebted to Carrie Springer for her invaluable advice, kindness, promotion of my work, and friendship. I am grateful to Peter Thompson for his critical reading of the preface and to Elizabeth Galst for her editorial and literary skills. Other colleagues, fellow photographers, artists, and friends contributed their support and provided helpful critique of the work-in-progress: Terry Evans, Lesley Martin, Mary Dougherty, Marietta Kesting, Lynn Sloan, Carol Ehlers, Patti Gilford, and Judith Raphael. I am grateful to Catherine Edelman for her enthusiastic

representation of my work. I thank Robert Coles, Caroline Jackson, and Betsy Brandes at *DoubleTake* magazine for their encouragement. Rich Cahan at the *City 2000* project came up with the wonderful idea of photographing at city pools. For countless hours of legal work, excellent advice, and friendship I am indebted to the generosity of my attorney Robert Horwitch, and no less to Barbara Horwitch, my genial advocate, for her warm friendship and supply of photo opportunities.

I am fortunate to have had the contributions of many talented friends at Columbia College Chicago. Thomas Shirley provided top-notch digital expertise. I thank Benjamin Gest for his painstaking and skillful efforts on the scans for reproduction. Thomas and Benjamin made it possible to translate the quality of my C-prints to the printed page. I am most grateful to Sarah Faust for her sensitive, elegant book design and for her patience. Many thanks to Christine DiThomas for her concise edit of the text. I thank the darkroom staff, especially Robert Linkiewicz and Steve Fukawa, for their assistance and cooperation. In the Digital Lab thanks go to Tammy Mercure, Jennifer Keats, and Eric Zorn for their help and expertise, and to Norman Alexandroff in the Publications Department for his support and advice. For the support of the College, my gratitude extends to Dr. Warrick Carter, President; Steven Kapelke, Provost; Bert Gall, Executive Vice President; Michael DeSalle, Vice President of Finance; and Leonard Lehrer, Dean of Fine and Performing Arts. At the Museum of Contemporary Photography I thank Rod Slemmons, Natasha Egan, Stephanie Conaway, Karen Irvine, Corrine Rose, and Deborah Peterson. Many thanks for excellent work to Thorsteinn Torfason and the staff at Oddi Printing Ltd. At the Center for American Places thanks go to Randall B. Jones for holding down the fort. I am grateful also to Jocelyn Nevel for her work on the Center's Website gallery and her support. At the *New York Times Magazine*, I thank Kathy Ryan and Kira Pollack for their encouragement. Natasha Lunn at the *New Yorker* was of great help. Many of the photographs in the book were made on assignment. I am grateful to all the families, brides, grooms, and Bat Mitzvah girls for providing these opportunities, especially Lila and Donald Vidger, Courtney and David Hollander, Nancy and Bruce Stevens, the VanderTuig family, the Sandler family, the Horwitch family, the Buch family, and the Reverend Terri Pilarski. A special thanks to our young friends Jolantha Eschrig, Alexandra and Isabel Wolcott, and Kiara Augustin. I am indebted to the many other wonderful people who generously allowed me to photograph them.

My love and gratitude go to my sisters and brothers—Glenn, Victoria, Sean, Lucinda, and Michael—and to my father, for being such compelling subjects, and for enduring, with forbearance and grace, all these years of being photographed. My nieces Christina, Tory, and Molly and my nephew Drew have been exuberant subjects. Thirteen years ago Ann and Herm Lehman—indeed the entire Lehman family—welcomed me with great warmth, camera and all. And, as in the tradition that the last shall be first, without my husband Roger Lehman the life with which I am now blessed would not exist. Roger is my touchstone and greatest advocate. He and Emma make everything possible—infinity times infinity—and that's a lot.

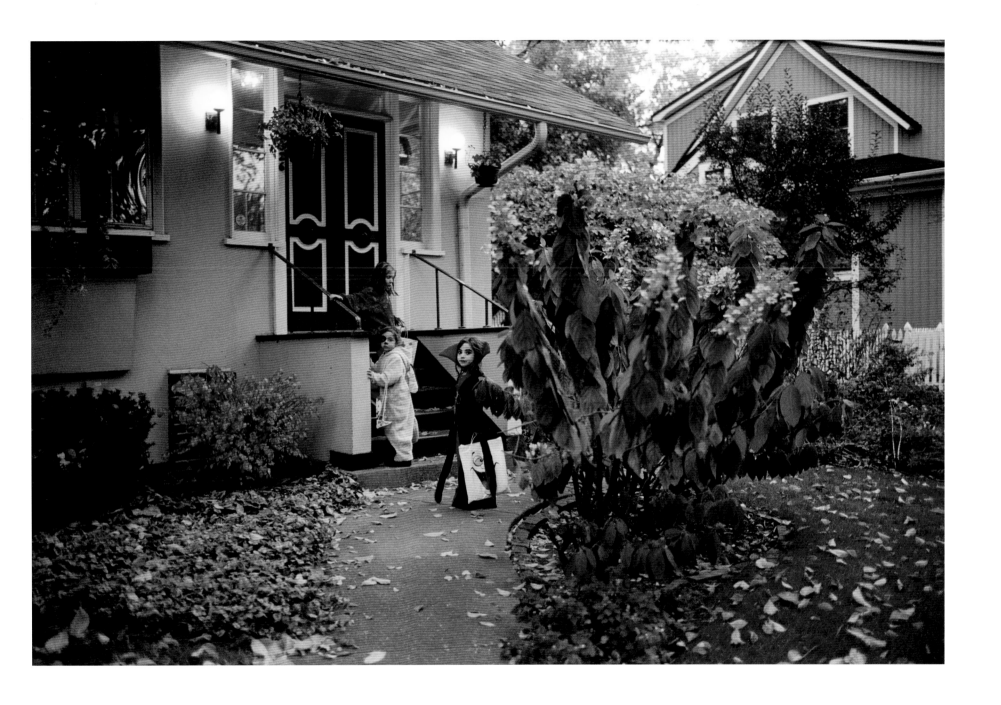

About the Author

Melissa Ann Pinney was born in St. Louis, Missouri, in 1953 and was raised in Scarsdale, New York, and Evanston, Illinois. She attended Manhattanville College, received her B.A. in photography from Columbia College Chicago in 1977, and completed her M.F.A. in photography at the University of Illinois at Chicago in 1988. She has received fellowships from the John Simon Guggenheim Memorial Foundation, National Endowment for the Arts, and the Illinois Arts Council, among others. Her photographs have been widely exhibited in the United States and abroad, and they are part of numerous collections, including those of the Art Institute of Chicago, the Center for Creative Photography in Tucson, the Metropolitan Museum of Art in New York City, the Museum of Modern Art in New York City, the San Francisco Museum of Modern Art, and the Whitney Museum of American Art in New York City. Her photographs have appeared in *DoubleTake*, the *New York Times Magazine*, *Ms.*, and *U.S. News and World Report*, among many other publications. Ms. Pinney has taught photography at Columbia College Chicago since 1984, and she resides with her husband and daughter in Evanston, Illinois.

About the Essayist

Ann Patchett was born in Los Angeles in 1963. She completed her B.A. at Sarah Lawrence College and her M.F.A. at the University of Iowa Writer's Workshop. Her first novel, *The Patron Saint of Liars* (1992), received a James A. Michener Copernicus Award for a book in progress, and it was adapted into a television movie for CBS in 1997. Her second novel, *Taft* (1994), was awarded the Janet Heidinger Kafka Prize for the best work of fiction. Her third novel, *The Magician's Assistant* (1997), earned her a John Simon Guggenheim Memorial Foundation Fellowship, and her fourth novel, *Bel Canto* (2001), received the PEN/Faulkner Award and England's Orange Prize. Ms. Patchett has also written for the *Boston Globe*, *Chicago Tribune*, *Gourmet*, *GQ*, *New York Times Magazine*, and *Vogue,* among numerous other publications. She resides in Nashville, Tennessee.

The Center for American Places is a tax-exempt 501(c)(3) nonprofit organization, founded in 1990, whose educational mission is to enhance the public's understanding of, and appreciation for, the natural and built environment. Underpinning this mission is the belief that books provide an indispensible foundation for comprehending—and caring for—the places where we live, work, and explore. Books live. Books endure. Books make a difference. Books are gifts to civilization.

With offices in New Mexico and Virginia, Center editors bring to publication 20–25 books per year under the Center's own imprint or in association with publishing partners. The Center is also engaged in numerous other programs that emphasize the interpretation of place through art, literature, scholarship, exhibitions, and field research. The Center's Cotton Mather Library in Arthur, Nebraska, its Martha A. Strawn Photographic Library in Davidson, North Carolina, and a ten-acre reserve along the Santa Fe River in Florida are available as retreats upon request. The Center is also affiliated with the Rocky Mountain Land Library in Denver, Colorado.

The Center strives every day to make a difference through books, research, and education. For more information, please send inquiries to P.O. Box 23225, Santa Fe, NM 87502, U.S.A., or visit the Center's Website (www.americanplaces.org).

About the Book

The text for *Regarding Emma* was set in Franklin Gothic with Filosofia display. The paper is acid-free Silk Gallery paper, 170 gsm weight. The four-color separations, printing, and binding were professionally rendered by Oddi Printing Ltd., of Reykjavik, Iceland.

FOR THE CENTER FOR AMERICAN PLACES:
George F. Thompson, President and Publisher
Randall B. Jones, Associate Editorial Director
Lauren A. Marcum, Editorial Assistant

FOR COLUMBIA COLLEGE CHICAGO:
Sarah Faust, Book Designer
Mary Johnson, Director of Creative and Printing Services
Christine DiThomas, Manuscript Editor
Benjamin Gest, Director of Digital Scans
Thomas Shirley, Coordinator of Digital Imaging
Bob Thall, Chairman, Photography Department